Contents

Introduction

Fashion drawing

Drawing is a skill that is fundamental to fashion design and fashion drawing. A fashion drawing is the means by which a fashion designer describes not only the shape of a garment but also shows how clothes are constructed, the type of fabrics used and other design details.

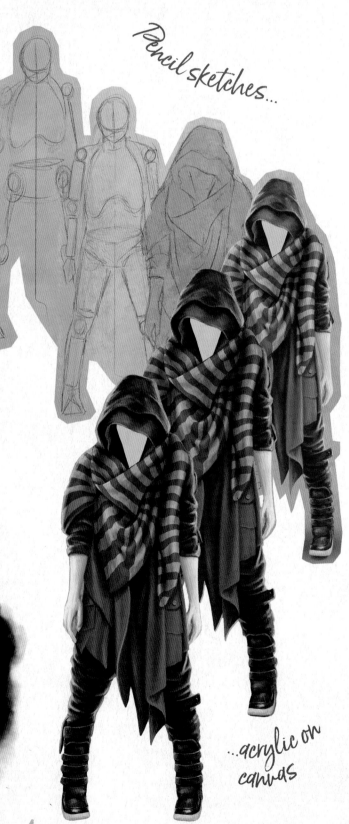

Pencil sketches...

...acrylic on canvas

Step-by-step

This book features work by a range of artists, highlighting how every fashion designer has different ways of working. To draw fashion figures it is important to study people moving and walking and note how their heads and bodies respond by twisting and turning. By using step-by-step stages this book aims to show how sketches of simple stick figures can be transformed into fabulous fashion drawings.

Inspiration and research

Inspiration and research are key elements for creative fashion drawing. Creating mood boards and personal sketchbooks packed with fashion ideas greatly energises all the design processes.

FASHION
Drawing
Carolyn Scrace

SCRIBO
a SALARIYA imprint

Published in MMXVIII by
Scribo, an imprint of
The Salariya Book Company Ltd
25 Marlborough Place, Brighton BN1 1UB
www.salariya.com

PB ISBN: 978-1-912233-68-7

SALARIYA
SCRIBO BOOK HOUSE SCRIBBLERS

3 5 7 9 8 6 4

Printed and bound in China.
Reprinted in MMXX.

Additional Artists: Michael Cheung, Debbi Edwards, Amarilys Henderson,
Kevin McGivern, Carol Robinson, Jennifer Skemp, and Shutterstock.

Visit
www.salariya.com
for our online catalogue and
free fun stuff.

PAPER FROM
SUSTAINABLE
FORESTS

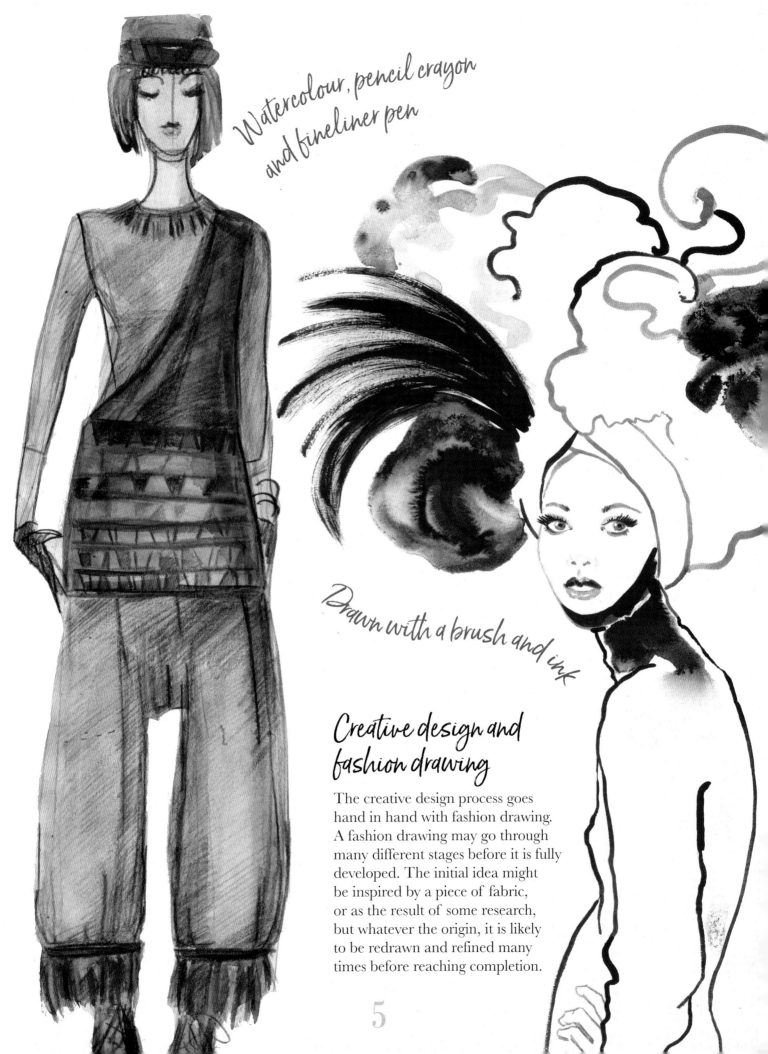

Watercolour, pencil crayon and fineliner pen

Drawn with a brush and ink

Creative design and fashion drawing

The creative design process goes hand in hand with fashion drawing. A fashion drawing may go through many different stages before it is fully developed. The initial idea might be inspired by a piece of fabric, or as the result of some research, but whatever the origin, it is likely to be redrawn and refined many times before reaching completion.

Fashion
A brief history

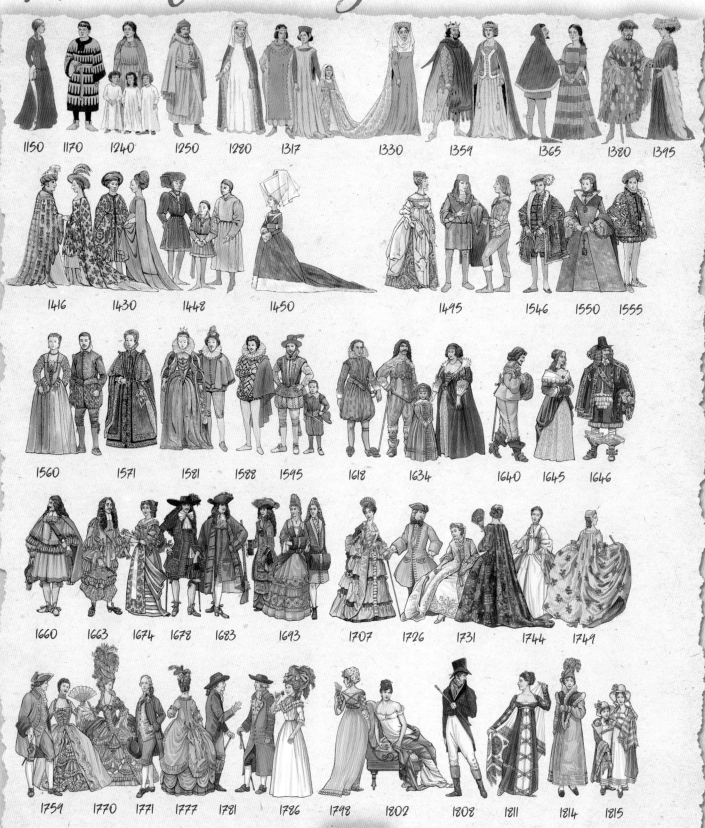

1150 1170 1240 1250 1280 1317 1330 1359 1365 1380 1395

1416 1430 1448 1450 1495 1546 1550 1555

1560 1571 1581 1588 1595 1618 1634 1640 1645 1646

1660 1663 1674 1678 1683 1693 1707 1726 1731 1744 1749

1759 1770 1771 1777 1781 1786 1798 1802 1808 1811 1814 1815

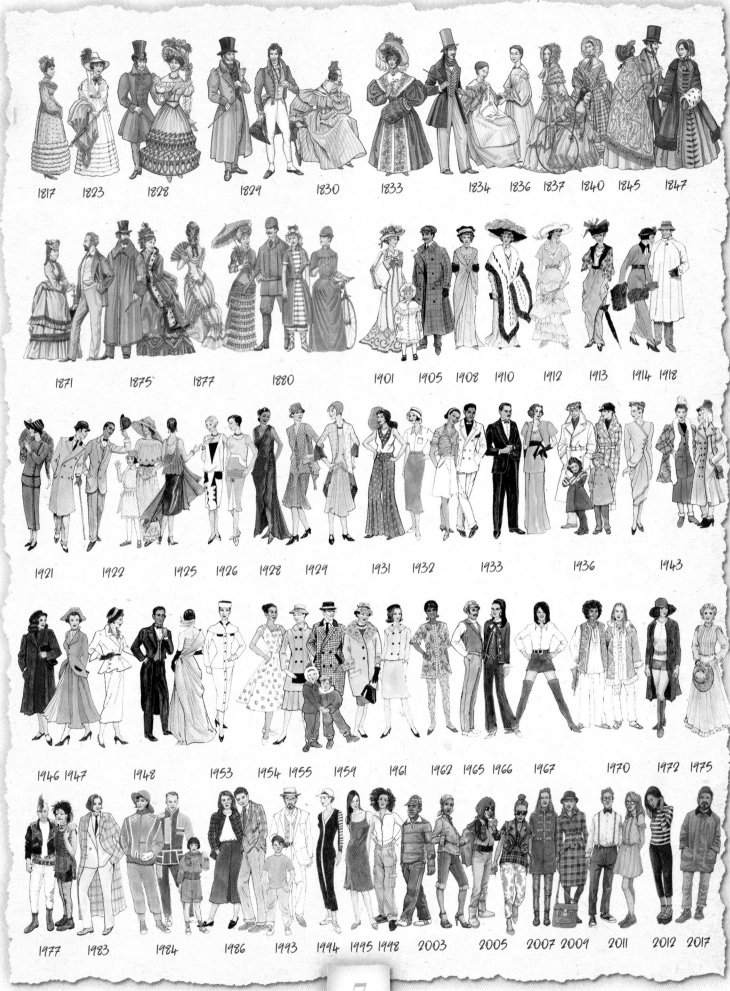

1817 1823 1828 1829 1830 1833 1834 1836 1837 1840 1845 1847

1871 1875 1877 1880 1901 1905 1908 1910 1912 1913 1914 1918

1921 1922 1925 1926 1928 1929 1931 1932 1933 1936 1943

1946 1947 1948 1953 1954 1955 1959 1961 1962 1965 1966 1967 1970 1972 1975

1977 1983 1984 1986 1993 1994 1995 1998 2003 2005 2007 2009 2011 2012 2017

Tools and materials
Pencils, pens and brushes

Scraps of paper and pencil!

For fashion drawing all you really need are some scraps of paper and a pencil. There are endless art materials that can be used, but just start with whatever you have to hand. The most important thing is to experiment – use whatever tools and materials that excite you and are fun to use.

Graphite pencils

These range from hard 6H pencils to soft 6B pencils.

Pencil crayons

Use for adding texture, shading and for blocking in pale colours.

Coloured fineliner pens

These produce a flowing line and are ideal for adding detail.

Black fineliner pens

Nibs widths range from 0.1 mm to 0.8 mm, and the ink is usually waterproof. These pens produce flowing lines.

Ballpoint pens

Ideal for fashion sketches on the go! Produce a variety of lines, soft to hard.

Metallic gel pens

These are ideal for adding touches of gold or silver detailing to a design.

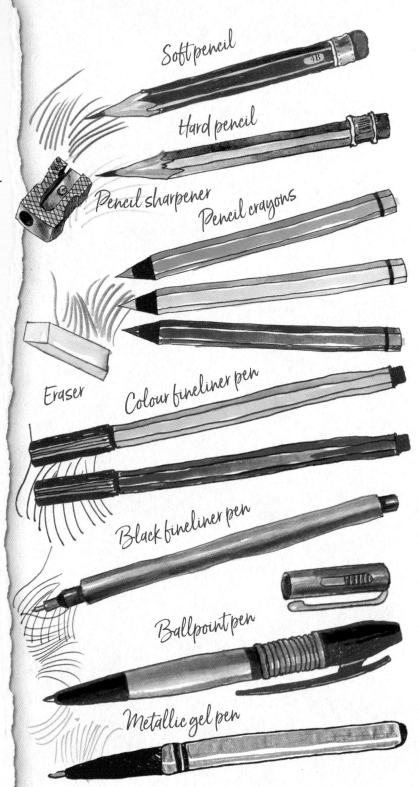

Soft pencil

Hard pencil

Pencil sharpener

Pencil crayons

Eraser

Colour fineliner pen

Black fineliner pen

Ballpoint pen

Metallic gel pen

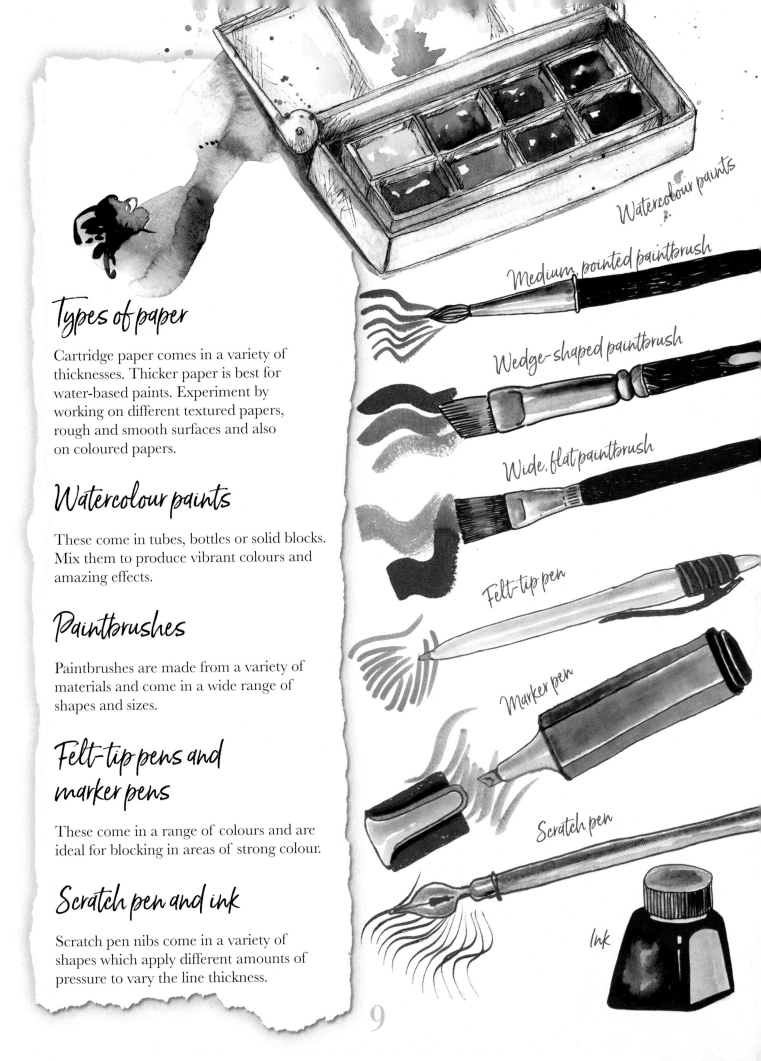

Types of paper

Cartridge paper comes in a variety of thicknesses. Thicker paper is best for water-based paints. Experiment by working on different textured papers, rough and smooth surfaces and also on coloured papers.

Watercolour paints

These come in tubes, bottles or solid blocks. Mix them to produce vibrant colours and amazing effects.

Paintbrushes

Paintbrushes are made from a variety of materials and come in a wide range of shapes and sizes.

Felt-tip pens and marker pens

These come in a range of colours and are ideal for blocking in areas of strong colour.

Scratch pen and ink

Scratch pen nibs come in a variety of shapes which apply different amounts of pressure to vary the line thickness.

Watercolour paints

Medium, pointed paintbrush

Wedge-shaped paintbrush

Wide, flat paintbrush

Felt-tip pen

Marker pen

Scratch pen

Ink

9

Shading techniques

Adding shading to specific areas of a fashion drawing can create a sense of three dimensions. It gives the effect of the drape and folds of a fabric and adds depth and movement to a design.

Hatching

Hatching builds up tone using a series of thin parallel lines. Drawing lines closer together creates darker tones.

Cross-hatching

Cross-hatching is when a second set of parallel lines criss-crosses the first. Add more sets of lines to create darker tones.

Scribbling

Use scribbling for shading various textures. To create darker tones, simply make the scribbles more dense.

Smudging

This is a useful technique for blending graphite pencil shading. Simply use the tip of your finger to smudge the pencil lines.

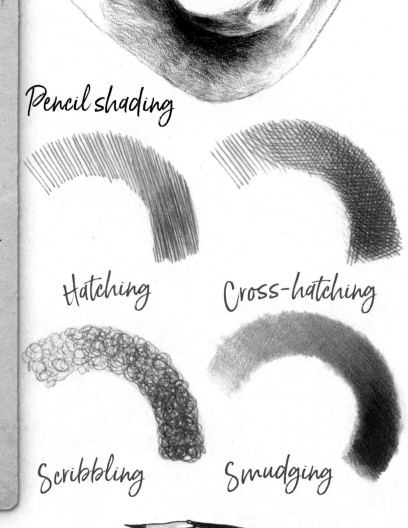

Pencil shading

Hatching

Cross-hatching

Scribbling

Smudging

10

Before and after

This drawing (right) of a cone, sphere, cube and cylinder looks flat and dull in comparison to the shaded version below.

Light source

Direction of light source

Copy the top drawing and use it to practise drawing light and shade. Before you add any shading, decide on the direction of the light source. Build up layers of tone gradually, leaving the lightest areas unshaded.

Tonal contrast

Tonal contrast, or the difference between the darkest and lightest areas, can help create a dramatic fashion drawing.

This drawing needs tonal contrast to accentuate elements of the design. Adding shading will help give the impression of depth and a sense of movement.

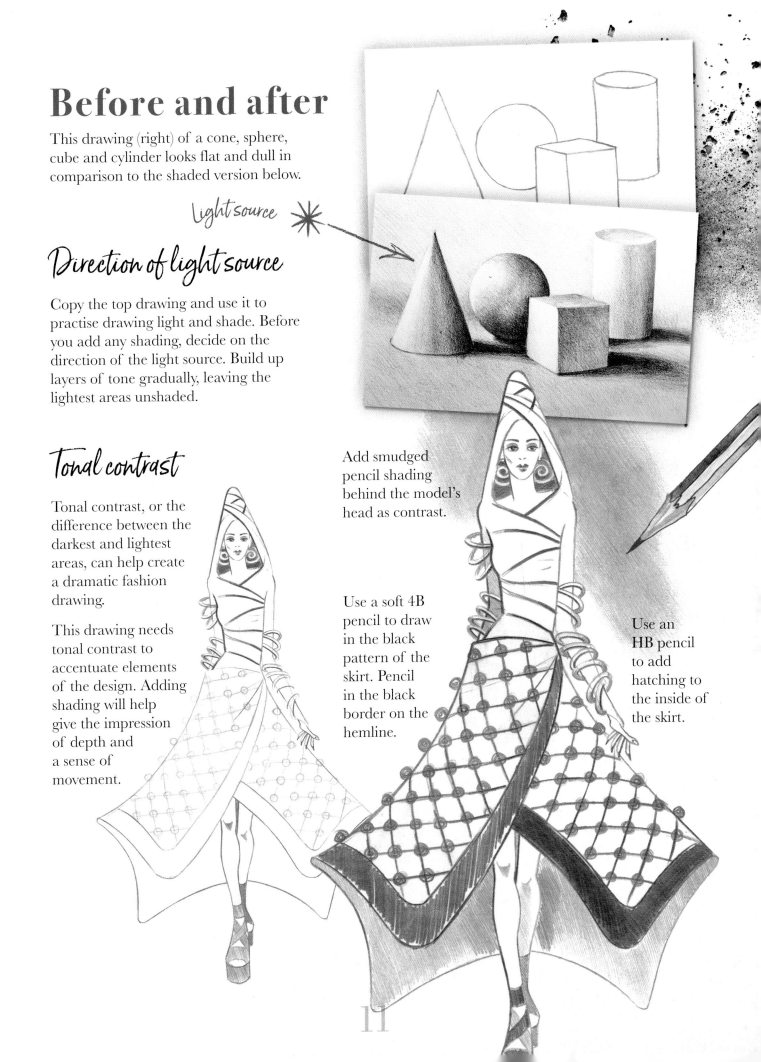

Add smudged pencil shading behind the model's head as contrast.

Use a soft 4B pencil to draw in the black pattern of the skirt. Pencil in the black border on the hemline.

Use an HB pencil to add hatching to the inside of the skirt.

11

Colour theory
The colour wheel

Primary colours

The three **primary** colours are red, yellow and blue. Primaries cannot be made by mixing any other colours. All colours are derived from them.

Secondary colours

Purple, orange and green are **secondary** colours. They are made by mixing two of the three primary colours (see above).

Tertiary colours

Red-orange, yellow-orange, yellow-green, blue-green, blue-purple and red-purple are **tertiary** colours. They are made by mixing a primary and a secondary colour.

Colour temperatures

Reds, oranges and yellows are **warm** colours associated with fire and earth.

Greens, blues and purples are **cool** colours associated with air and water.

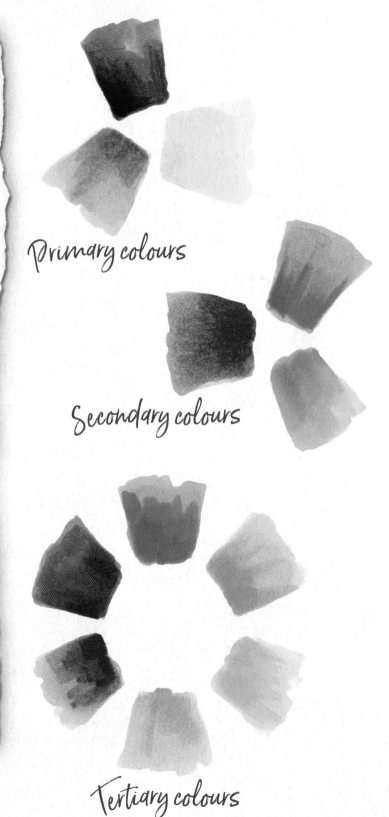

Primary colours

Secondary colours

Tertiary colours

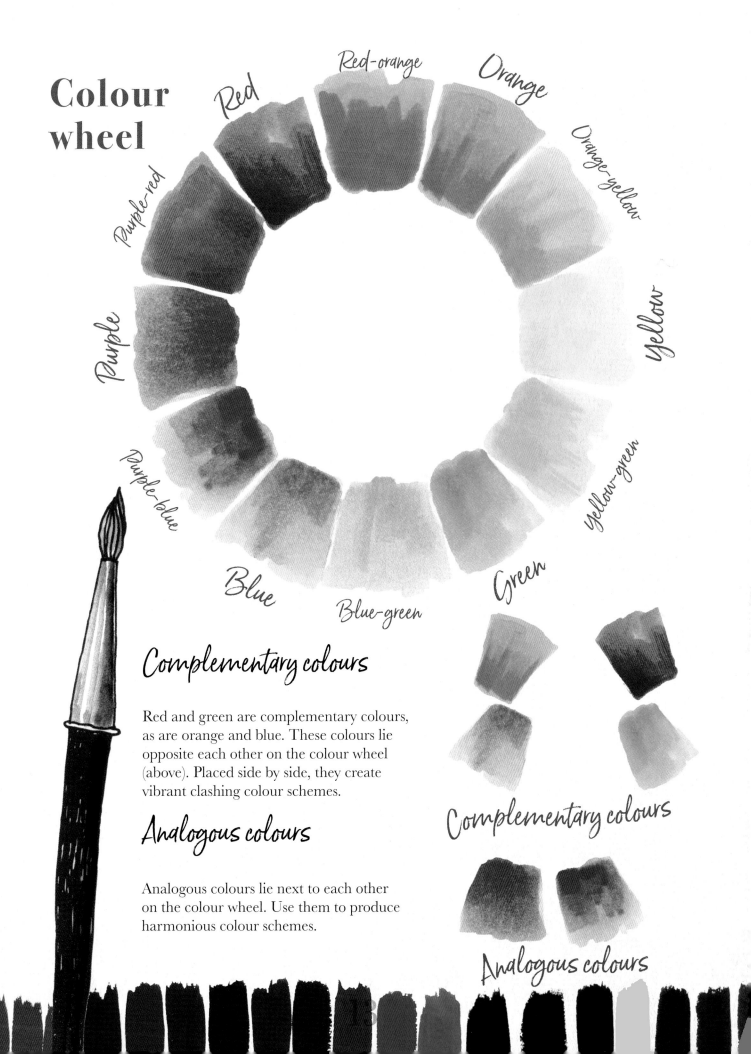

Colour wheel

Purple-red

Red

Red-orange

Orange

Orange-yellow

Yellow

Yellow-green

Green

Blue-green

Blue

Purple-blue

Purple

Complementary colours

Red and green are complementary colours, as are orange and blue. These colours lie opposite each other on the colour wheel (above). Placed side by side, they create vibrant clashing colour schemes.

Analogous colours

Analogous colours lie next to each other on the colour wheel. Use them to produce harmonious colour schemes.

Complementary colours

Analogous colours

Colour and pattern
Limited palette

Limited palette

A limited palette was used to colour in both of these fashion drawings. Restricting the number of colours used tends to produce easier colour harmonies and helps you to unify the different elements in your fashion design.

Colour swatches

Try out different colour combinations before colouring in your fashion drawing. Once you have chosen the colour scheme, it is a good idea to create a colour swatch for the design and keep it to hand as you work.

Technique

Both fashion drawings were drawn in a combination of fineliner pen and waterproof felt-tip pens in a variety of thicknesses.

Smudged pastel scribbles

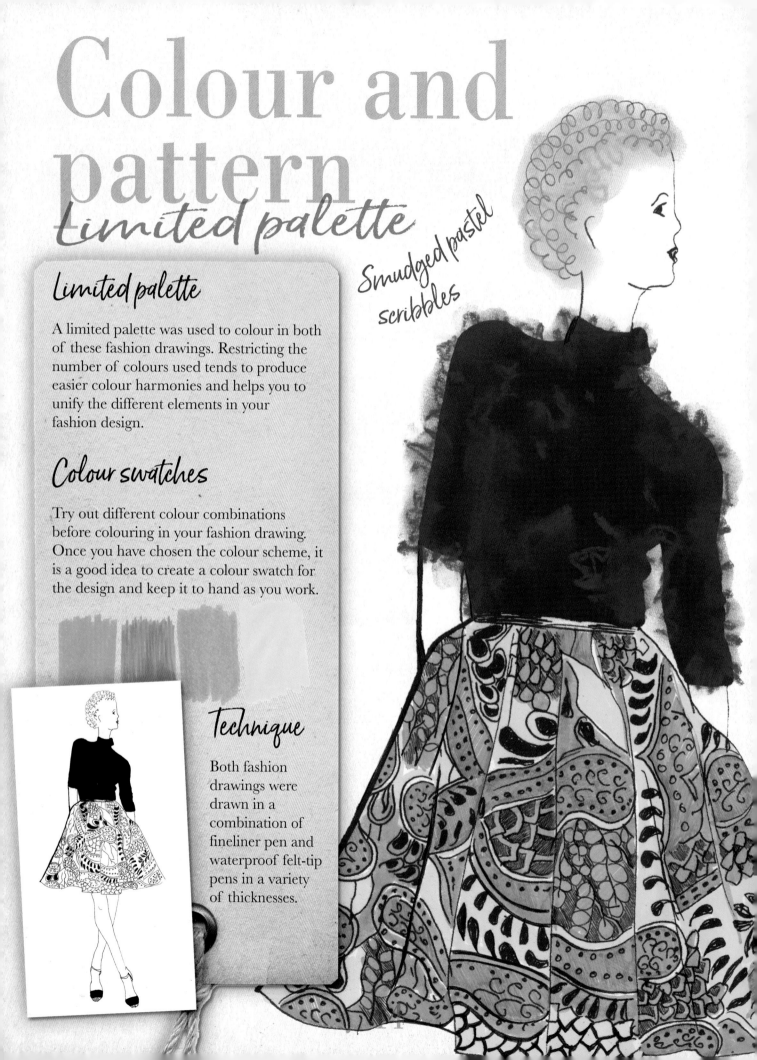

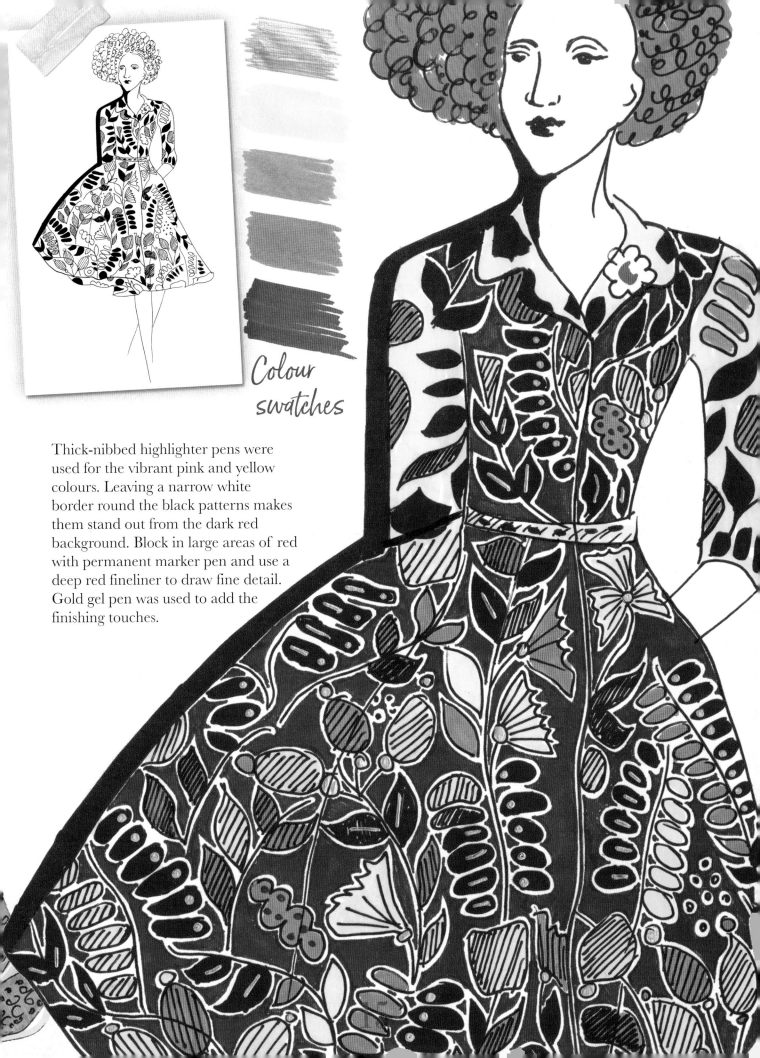

Colour swatches

Thick-nibbed highlighter pens were used for the vibrant pink and yellow colours. Leaving a narrow white border round the black patterns makes them stand out from the dark red background. Block in large areas of red with permanent marker pen and use a deep red fineliner to draw fine detail. Gold gel pen was used to add the finishing touches.

Female figure

Standard proportions

To draw the standard proportions of a female figure, the length of the head should fit seven to eight times into the body (example right). For fashion drawing, ten head lengths are generally used to gauge the figure's elongated body height.

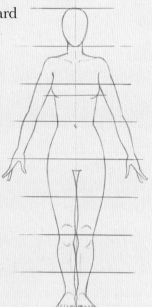

Stylised figures

Most fashion designers draw highly stylised figures in order to communicate their design ideas. They elongate figures, and use body proportions very different from normal human body proportions.

Stylised figure

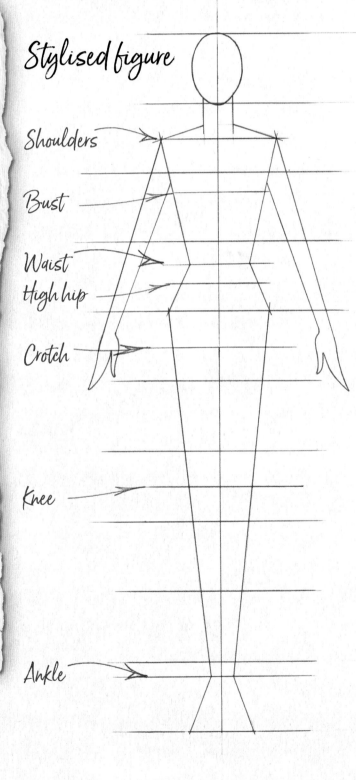

Shoulders

Bust

Waist
High hip

Crotch

Knee

Ankle

To draw a figure walking, the angle of the shoulder line should be opposite to that of the waist and hip lines.

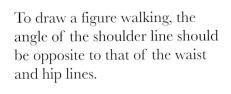

Indicate the eyeline, the base of the nose and the mouth. Add her collar bone, then draw in the curved shape of her bust.

Pencil in the model's features and hair plaited in a spiral. Design a jumpsuit based on a bold zigzag pattern. Add thigh-high boots. Use a 2B pencil to add shading.

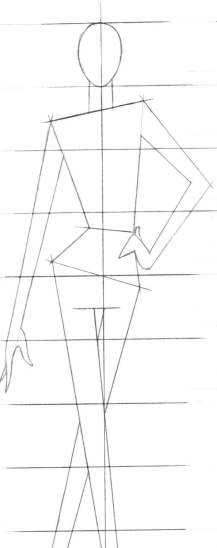

Collar bone

The shoulder line tilts upwards while the hip line tilts in the opposite direction. One leg steps forward in front of the other and the model's left arm is bent with her hand resting on her hip.

Now pencil in curved shapes to soften the outline of the body. Round off the sharp angles of the shoulders and hips. Erase any unwanted construction lines.

Different views
Body movement

Three-quarters and side views

Some fashion designs benefit from being drawn from a side or three-quarters view. As these poses are slightly harder to draw it's worth practising them. Note the direction of movement of the top two figures and the angles of the hips, waist and shoulders. Study people walking, to see how they swing their arms and legs in alternate directions. Ask friends to pose for you while you sketch them from different angles.

Showing off detail and styling

Three-quarter and side views can be ideal for highlighting special details such as pockets and seams.

Showing movement

Walking poses create movement in fabrics as in the striped coat design (opposite). Drawing the model glancing back over her shoulder with her arms widespread also adds jauntiness to the image.

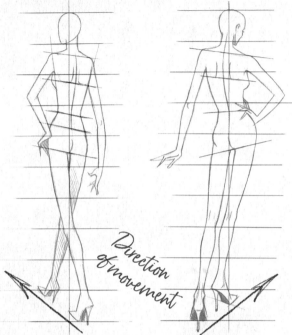

Direction of movement

Three-quarters back view

Back view

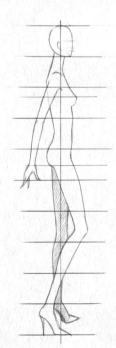

Side view

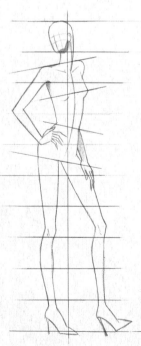

Three-quarters side view

Step-by-step

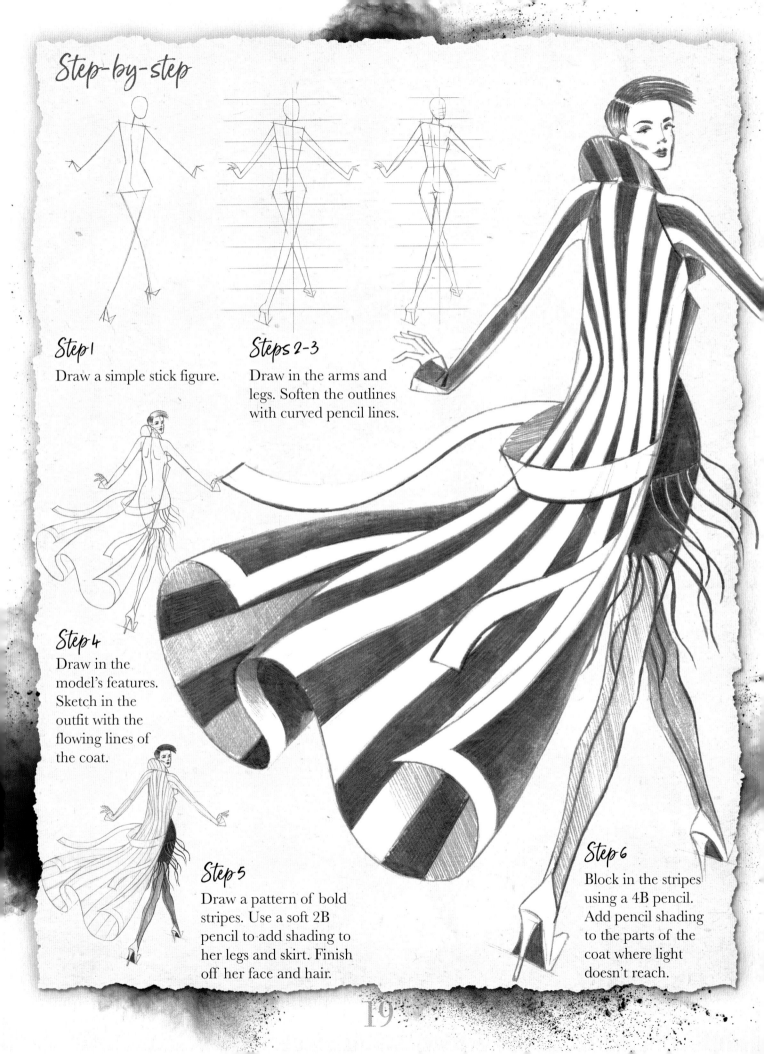

Step 1

Draw a simple stick figure.

Steps 2-3

Draw in the arms and legs. Soften the outlines with curved pencil lines.

Step 4

Draw in the model's features. Sketch in the outfit with the flowing lines of the coat.

Step 5

Draw a pattern of bold stripes. Use a soft 2B pencil to add shading to her legs and skirt. Finish off her face and hair.

Step 6

Block in the stripes using a 4B pencil. Add pencil shading to the parts of the coat where light doesn't reach.

Heads and faces
Step-by-step

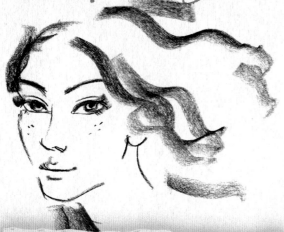

F ollow the instructions, then practise drawing simple faces. Once your confidence has grown, start to experiment with different styles of make-up, then have fun adding extraordinary hairstyles.

Exaggerated features

In fashion drawing the facial features tend to be exaggerated – the eyes and mouth are larger and the nose is smaller. Detail is usually concentrated on the eyes, eyebrows and mouth.

Step 1
Draw an elongated egg shape. Pencil in a vertical line through the centre. Add horizontal lines along the top and bottom.

Step 2
Add horizontal lines to mark the position of the eyes, nose and mouth. The eyeline is about halfway down.

Step 3
Draw in the eyes, mouth and nostrils. The gap between the eyes should be the width of an eye.

Step 4
Draw in the features, adding details to the eyes and lips. Draw in the ears, and add shading to the face.

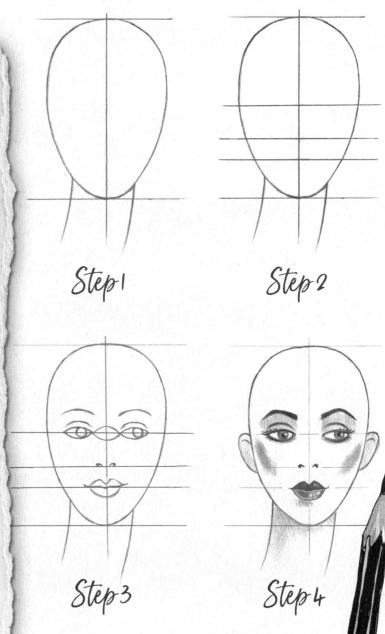

Step 1

Step 2

Step 3

Step 4

20

Side view

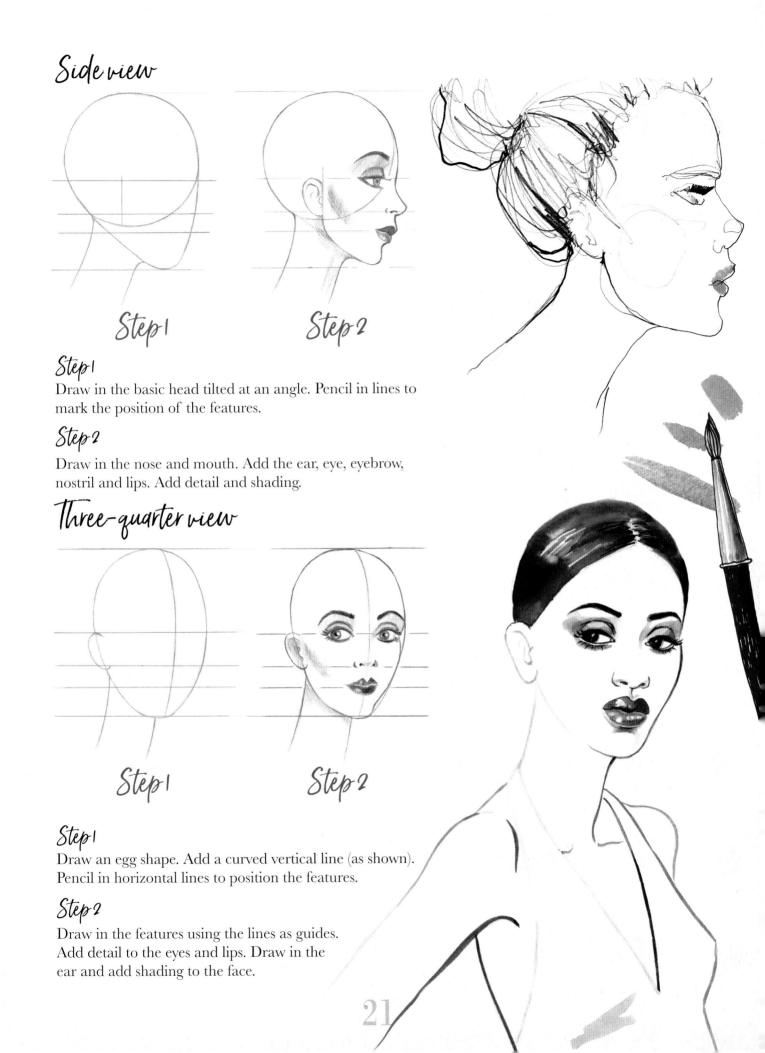

Step 1

Step 2

Step 1

Draw in the basic head tilted at an angle. Pencil in lines to mark the position of the features.

Step 2

Draw in the nose and mouth. Add the ear, eye, eyebrow, nostril and lips. Add detail and shading.

Three-quarter view

Step 1

Step 2

Step 1

Draw an egg shape. Add a curved vertical line (as shown). Pencil in horizontal lines to position the features.

Step 2

Draw in the features using the lines as guides. Add detail to the eyes and lips. Draw in the ear and add shading to the face.

Hands

Elegant and simple

In fashion drawings, hands and feet are kept elegant and simple so they don't detract from the outfit.

A circle and rectangle shape

For each of these hand positions pencil in a circle and a rectangle for the hand shape. Then draw lines to indicate the angle and directions of the fingers.

Slender fingers

Draw in the fingers and thumb – keep them long, slender and elegant. Round off any sharp angles. Add fingernails.

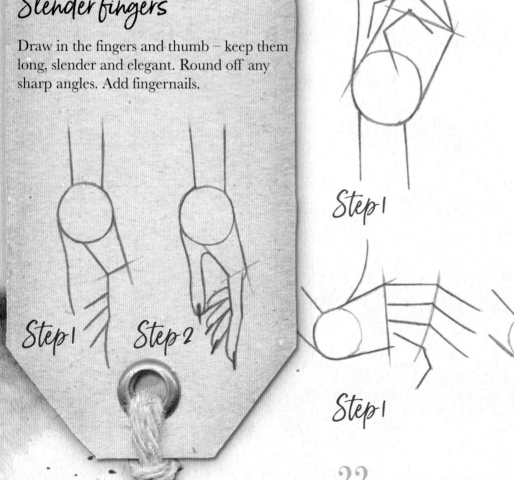

Step 1 Step 2

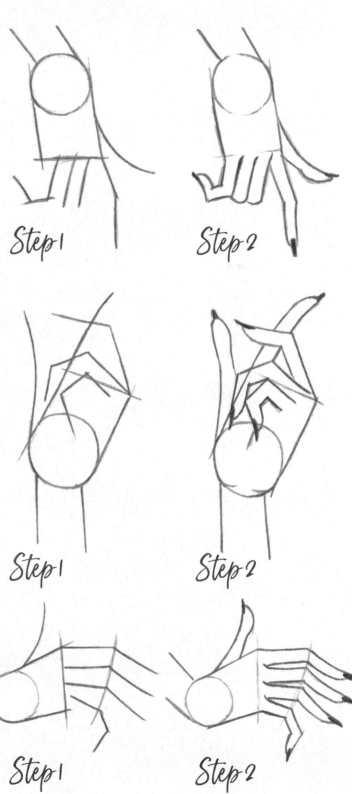

Step 1 Step 2

Step 1 Step 2

Step 1 Step 2

Feet

A circle and rectangle shape

For each of these views, start by pencilling in a circle and a rectangular shape for the foot.

Heel and ankle

Finish drawing the heel and ankle. Round off any sharp angles. Draw in the shape of the shoe (as shown).

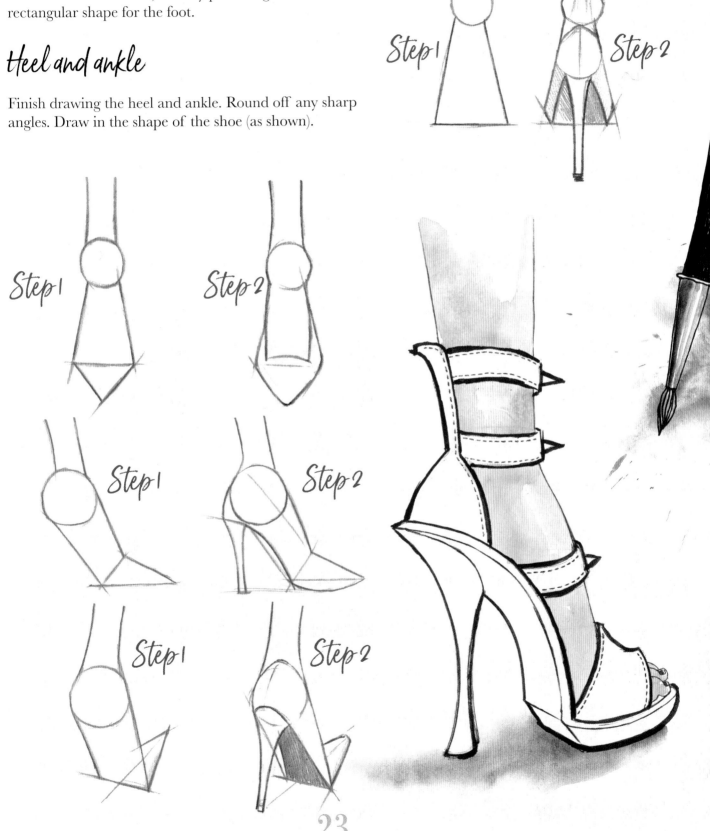

23

Male proportions
Body movement

Male figure

To draw the standard proportions of a male figure, the length of the head should fit eight times into the body. For fashion drawings of men, ten head lengths are generally used to gauge the figure's height.

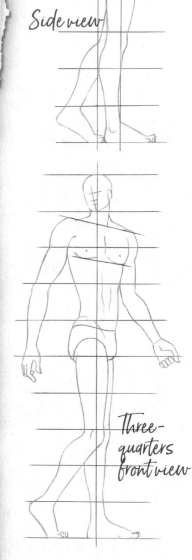

Side view

Three-quarters front view

Shoulders

Chest

Navel

Crotch

Fingertips

Base of knees

Shoulders

Chest

Navel

Crotch

Fingertips

Base of knees

Standard proportions

Proportions used for a male fashion drawing

Male fashion magazines are useful sources of inspiration for model poses. It's vital to think how best to show the particular shape and style of the garments.

Step-by-step

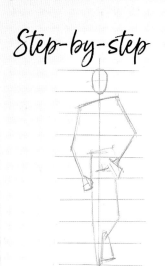

Step 1

Use pencil guidelines to draw in a simple stick figure.

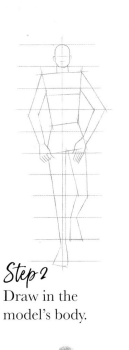

Step 2

Draw in the model's body.

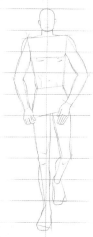

Step 3

Draw in curved lines to soften all sharp angles.

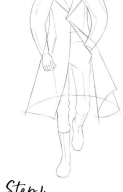

Step 4

Draw the model's face, hair and beard. Add the sweeping shape of his coat, the sleeves, collar and lapels.

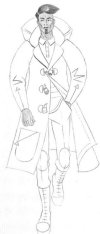

Step 5

Add skin tone and all finishing details to the outfit.

Step 6

Pencil in the striped lining of the coat and hood. Add similar pattern detail to the pocket and knee pads. Add shading to the stripes and other details. Darken areas where light wouldn't reach.

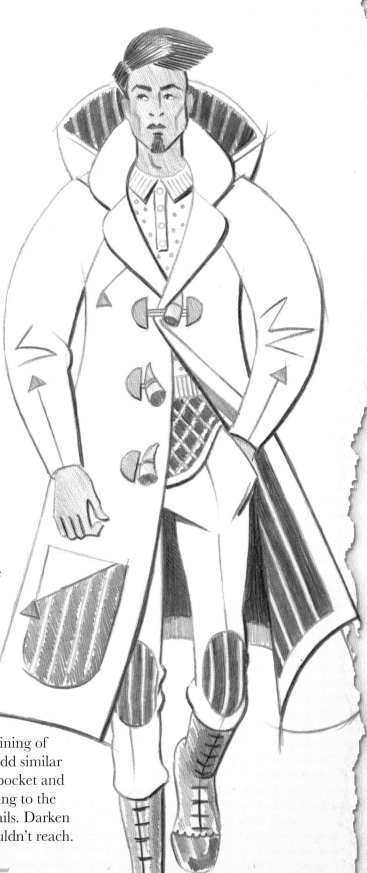

Types of fabric

To create stylish fashion drawings, it is important to be able to draw different types of fabric quickly and simply. Practise drawing a range of materials to see how they drape. Pay attention to fashion details like folds, gathers and pleats.

Chiffon

The fabric for this skirt has been drawn using three different techniques. Use a soft 6B pencil to draw the fabric then add smudged coloured pastel to create the effect of chiffon.

Tulle with sequins

To give the appearance of tulle and sequins try adding pencil spots to coloured ink fingerprints.

Fine pleated silk

3B scribbled pencil lines produce the effect of a fine accordion-pleated silk fabric for the bottom layer of the skirt.

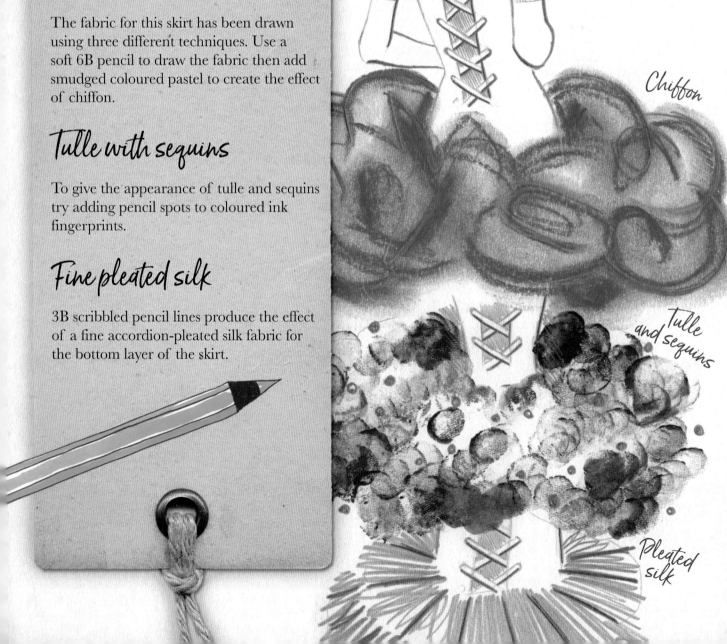

Chiffon

Tulle and sequins

Pleated silk

Collars and pocket

Look at the structure of different types of collars and pockets. Practise drawing them.

Exaggerate the size of buttons and buttonholes for added detail and interest.

Shade in the collar. Try leaving highlights to make it look shiny.

Draw in a bold diagonal check to reflect the angles of the collar. Add pencil scribbles to the peplum for a textured effect.

Peplum

Pleats and gathers

To draw these pleats, start at the waistline. Draw a series of strips that widen towards the hemline.

To draw soft pleats and gathers, start by sketching in the outline of the skirt shape. Choose your light source and use a soft pencil to add darker shading to areas of the fabric where the light doesn't reach. Use a hard pencil to add shading to lighter areas.

Light source

Hemline

Gathers

Before you draw the pleated hemline, study the way fabric folds to form pleats. Draw the hemline and add shading.

For added interest, draw in details such as side seams. A central crease line also creates a more 3D appearance.

This pencilled zigzag line indicates the position of the knees. Simple curved lines at the trouser bottoms indicate gathered folds at the ankles.

27

Mood board
Style

Theme of a collection

A fashion mood board is a type of collage made up of lots of different elements taken from your research, then arranged together to create your collection theme.

Large scale

It's a good idea to work on a fairly large scale; an A3 sheet of thick card or a pin board would be ideal. You will need a range of materials: images cut out of old magazines, photographs, examples of patterns, colours, drawings, sketches and fabric swatches. You might have a theme in mind, perhaps inspired by a period in history, a place, or a specific textile. You may want to select a random collection of visual 'clues' that may inspire you when arranged together.

Connections

Keep moving different elements of the collage around until you can see how things connect by way of colour schemes, shapes or patterns. Once a theme has become apparent, discard any irrelevant elements before you glue or pin the collage down. Treat your mood board as an ongoing project and add more to it as and when you find relevant things.

28

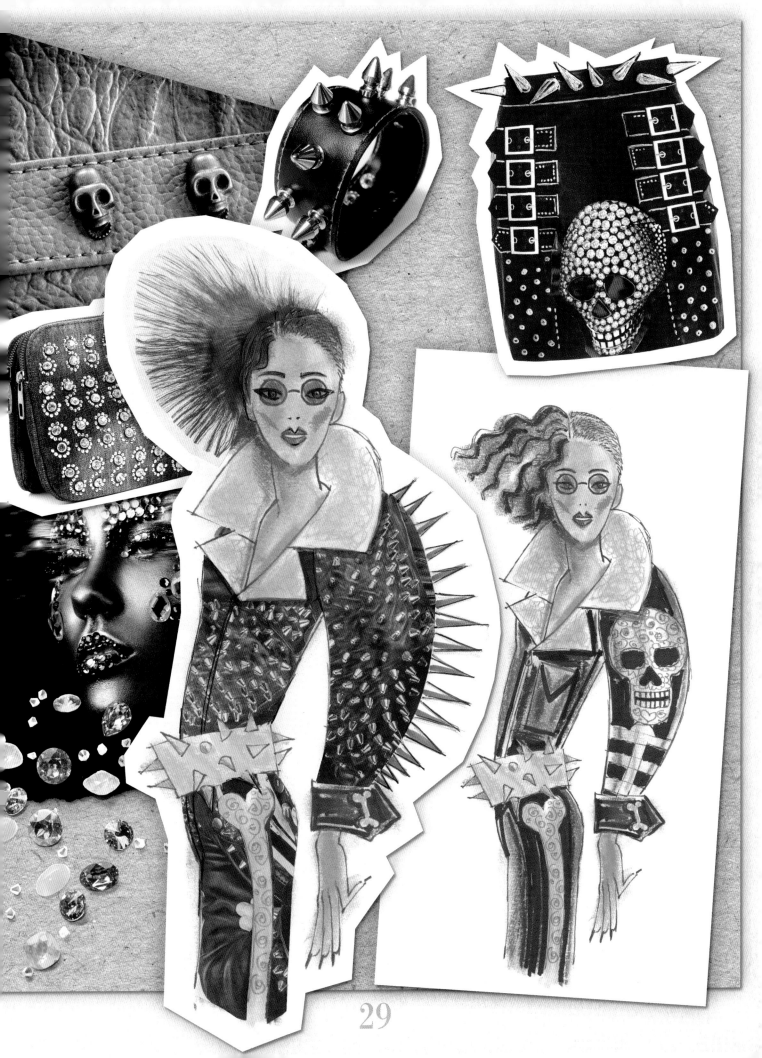

Mixed media
New techniques

Experiment!

Fashion drawings can be as free and experimental as you wish to make them. Using mixed media is a great way of trying out new techniques and combinations of materials. These fashion drawings were worked in pencil, pencil crayon, inks and watercolours.

Pencil and wash

Step 1

Use a pencil to lightly sketch in the main shapes of the fashion figures.

Step 2

Then paint skin-coloured watercolour on the models' faces, necks, arms, hands and legs. Leave to dry. Now paint the rest of the drawings with watercolour washes. Allow the different colours to run and bleed to create exciting results. Leave to dry.

Step 3

Use pencil crayons to draw in the faces and garments and add richer tones, colours and patterns.

Step 4

Use black fineliner pen to sketch in random outlines and to add fine details.

Pencil crayon hatching

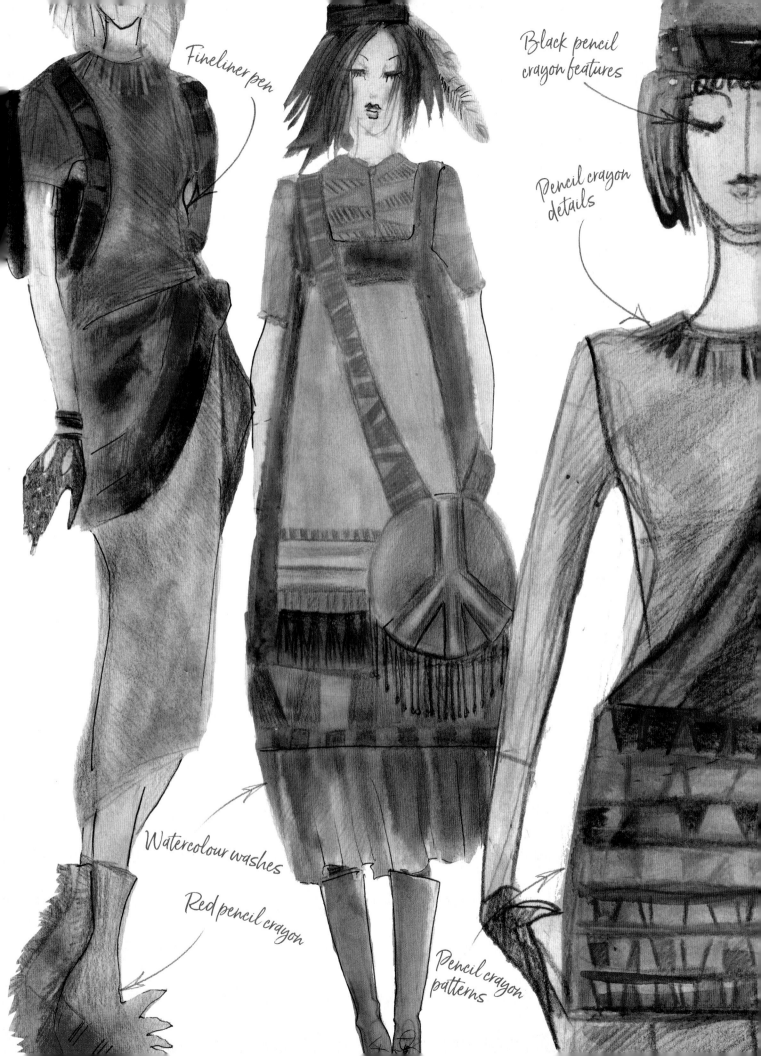

Fineliner pen

Black pencil
crayon features

Pencil crayon
details

Watercolour washes

Red pencil crayon

Pencil crayon
patterns

Watercolours
Boho style

Ways of working

Every fashion designer has different ways of working. Sometimes an artist will develop a design by producing a series of rough sketches. In other instances they may create their finished artwork in a few simple steps (as shown).

Stick figure

Step 1

Pencil in a simple stick figure. The model is shown in a relaxed pose, strolling forward.

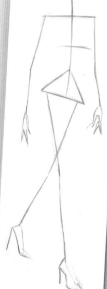

Step 3

Erase any unwanted pencil lines. Use a medium-sized pointed brush and watercolour paints to loosely draw the outline of the figure. Leave to dry. Start blocking in areas of tone, letting the watercolours bleed.

Finished sketch

Step 2

Lightly sketch in the model's body and facial features, and her clothes and hat. Draw in her sunglasses, boots and necklace.

Step 4

When dry, paint in darker tones such as creases in the fabric and shadows. Use a small paintbrush to add fine detail.

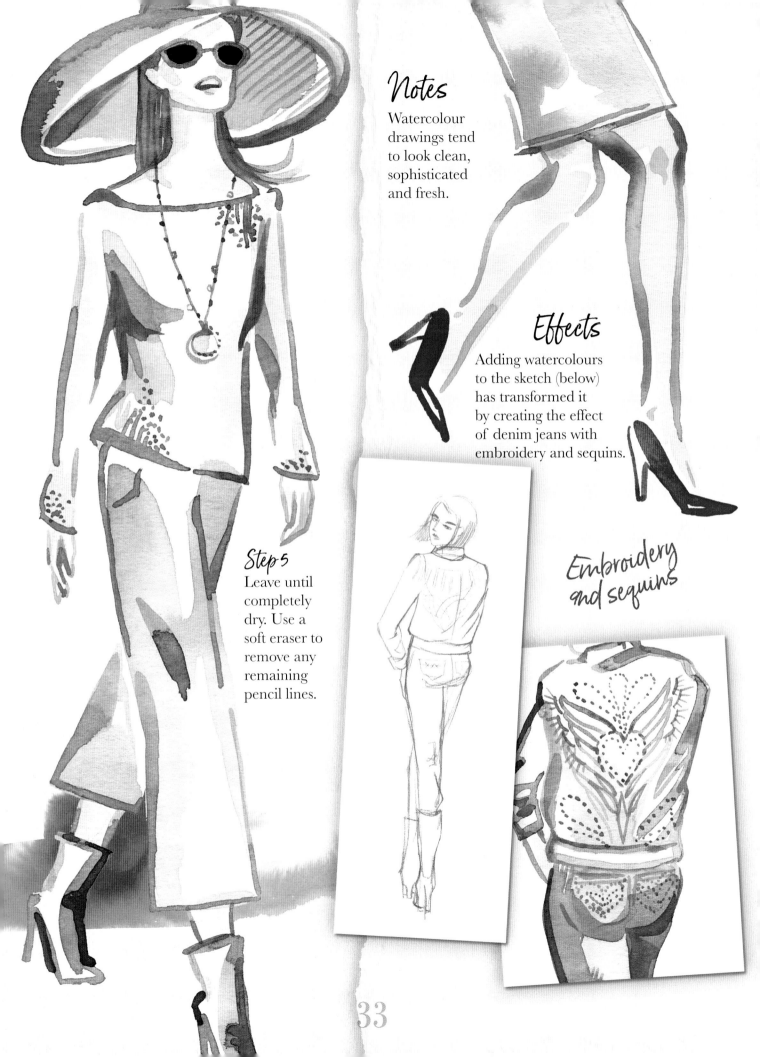

Notes
Watercolour drawings tend to look clean, sophisticated and fresh.

Effects
Adding watercolours to the sketch (below) has transformed it by creating the effect of denim jeans with embroidery and sequins.

Step 5
Leave until completely dry. Use a soft eraser to remove any remaining pencil lines.

Embroidery and sequins

City chic!
Urban style

Practise drawing figures as much as you can. Aim to do at least one drawing a day. Draw figures from life whenever possible and never feel embarrassed to be seen drawing in public. Fashion drawing is a skill that, once mastered, you will develop into your own personal style.

Starting with a pose

Sometimes a fashion drawing can be inspired by a pose. In this instance, the model is shown strutting forward.

Where and when?

Think about where and when the model will wear the clothes you are designing. Imagine, for example, that she is on her way to work in the city. For practicality, she wears a knee-length coat over a full skirt. Using a bold tartan check in contrasting orange and grey for her coat, skirt and tights helps to unify the look.

Emphasise

Emphasise the rounded shapes of the sleeves, coat and skirt. Add jaunty high-heeled boots topped with lace frills.

Step 1

Draw a simple stick figure.

Step 2

Indicate her hipline and the front of her body.

Step 3

Use curved lines to draw in the shape of the model's arm, body, legs and feet.

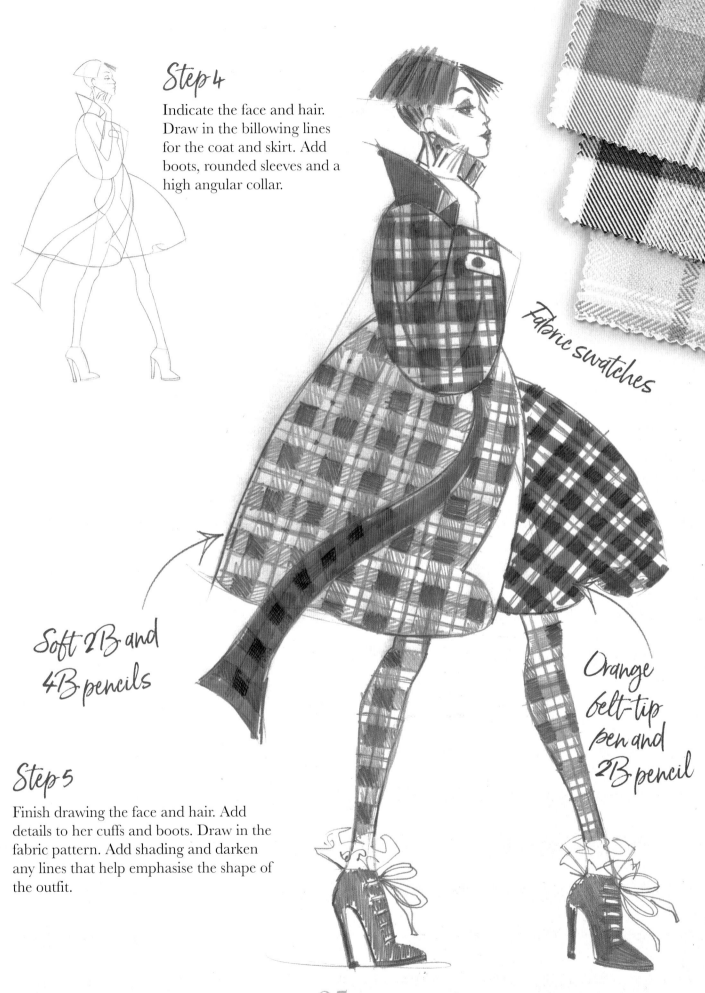

Step 4

Indicate the face and hair. Draw in the billowing lines for the coat and skirt. Add boots, rounded sleeves and a high angular collar.

Fabric swatches

Soft 2B and 4B pencils

Orange felt-tip pen and 2B pencil

Step 5

Finish drawing the face and hair. Add details to her cuffs and boots. Draw in the fabric pattern. Add shading and darken any lines that help emphasise the shape of the outfit.

Adding garments

Ink and crayon

This fashion figure was painted in black ink on watercolour paper. For a step-by-step guide to drawing in ink with a paintbrush, turn to pages 48–49. The hair is created by wetting a circular area around the face with clean water and adding black ink. Let it bleed.

Colour palette

Select your colour palette, in this example black, blue and purple. Pencil in the main shapes of the model's dress, then use coloured crayons to finish the dress design.

Colour palette

Pencil outline

Fringed skirt

Platform shoes

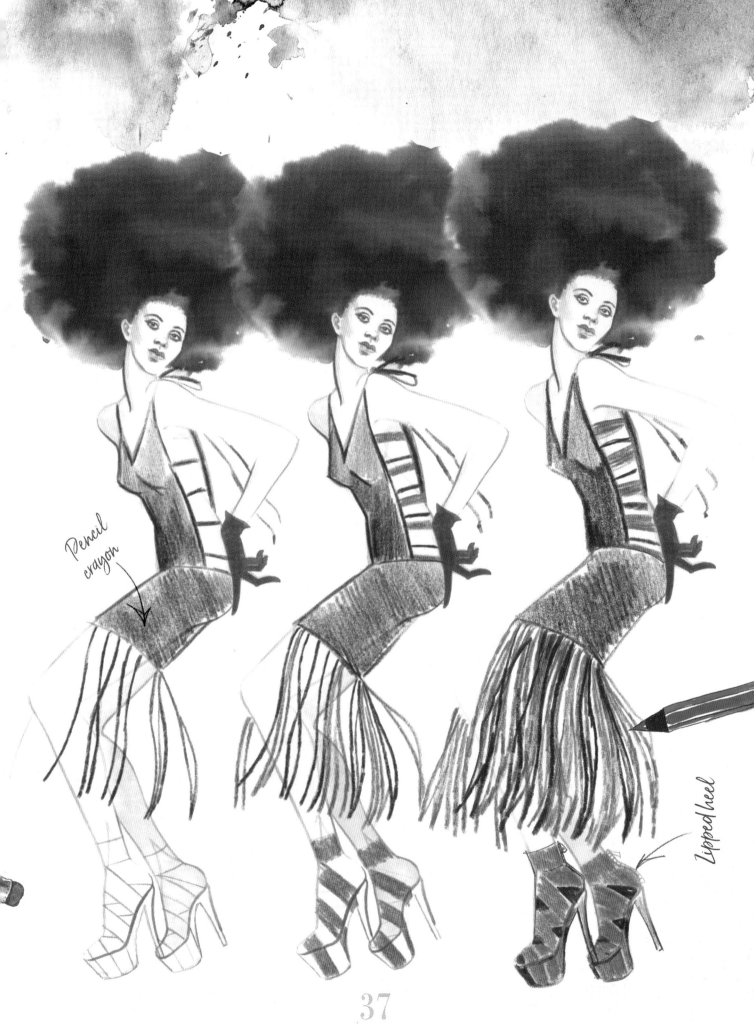

Pencil crayon

Zipped heel

37

Flamenco...
Spanish style

Transform

Now transform the same drawing by designing a completely different dress and shoes.

Flamenco dancers

The flamboyant costumes of Spanish flamenco dancers inspired this fashion design. The skirt has three gathered layers with a white frilled underskirt. A bold ruffled neckline and tight, fitted belt complete the outfit.

Ruffled neckline

Three-tiered skirt

Frilled underskirt

Platform shoes

Flamenco dancers

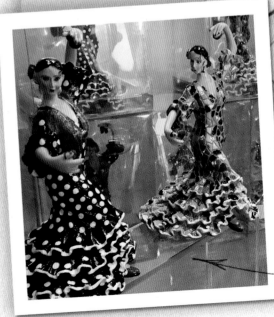

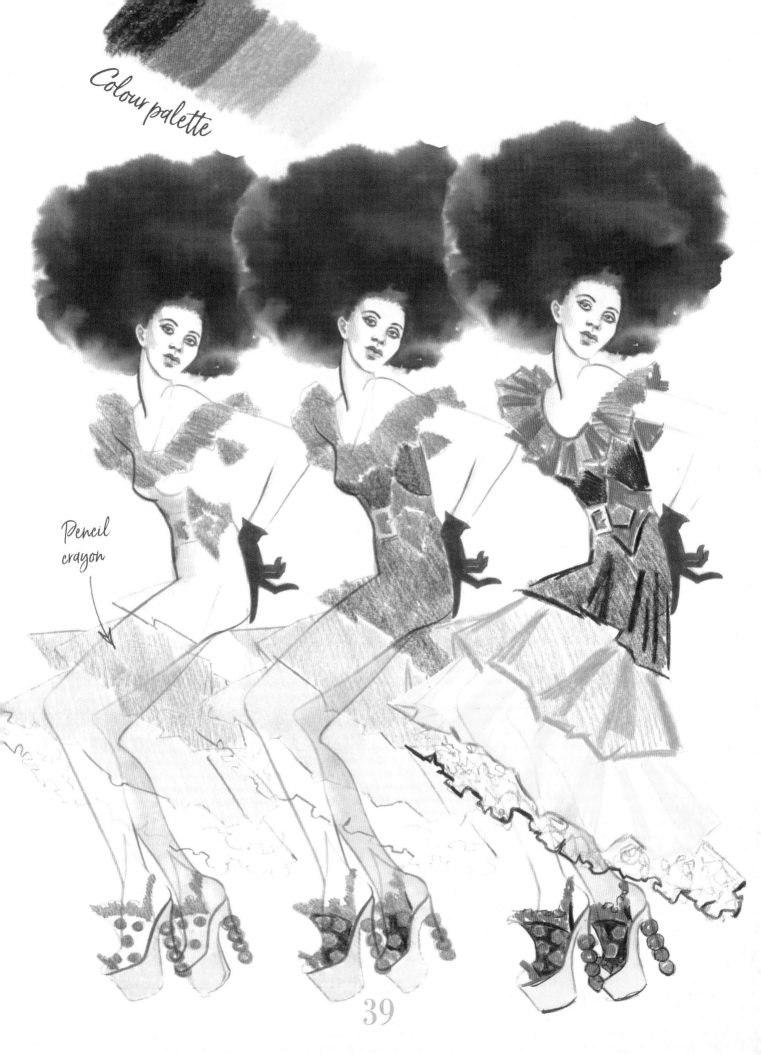

Colour palette

Pencil crayon

39

Transform...
Experimentation

Original sketch

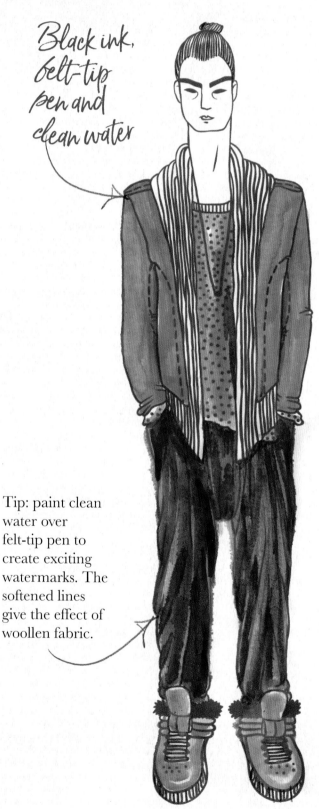

Black ink, felt-tip pen and clean water

Tip: paint clean water over felt-tip pen to create exciting watermarks. The softened lines give the effect of woollen fabric.

Transform the look!

See how you can totally change the look of a fashion drawing by using different textile combinations and colour schemes.

Make copies

Draw a fashion figure or figures. Then photocopy or scan and print out several copies of the image. Experiment by using different artistic techniques and try out a selection of patterns and textures.

Collage

Old fashion magazines are a fantastic source for images of different fabrics. Create coloured collages (right) with your cuttings and combine them with paint, felt-tip pen and fineliner pen.

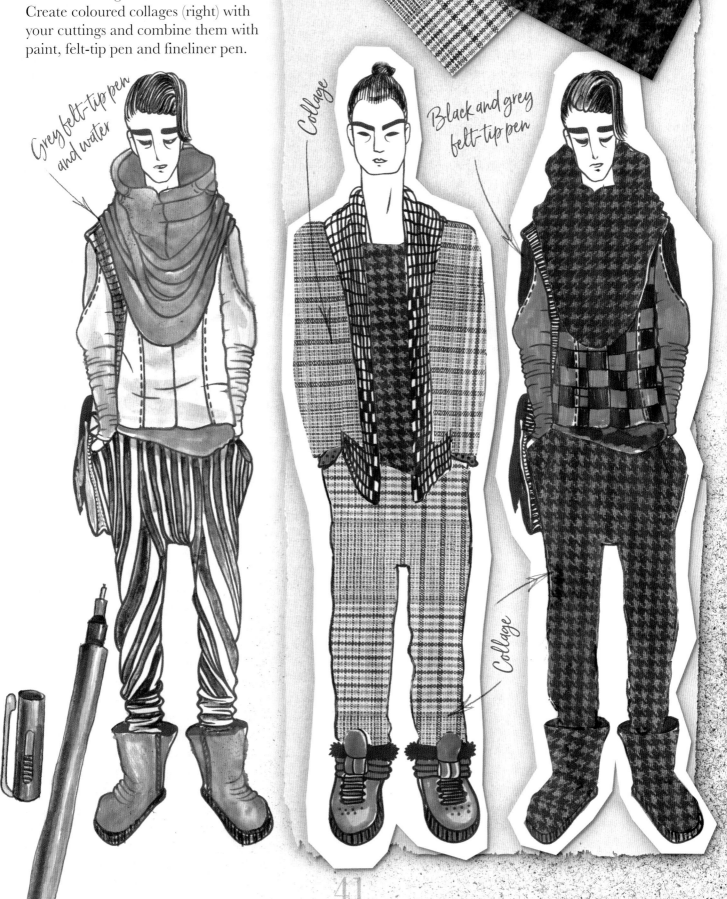

Grey felt-tip pen and water

Collage

Black and grey felt-tip pen

Collage

Textile themes
Contrasting fabrics

Choose a theme

Many fashion designers take a single theme as the basis of their catwalk show. This gives them the opportunity to explore an idea and experiment by trying out many different combinations of garments, shapes and textiles.

Japanese kimono

Design examples 1 and 2 (right) take the pattern of a Japanese kimono as their theme. The soft, delicate pattern of the kimono creates a strong contrast with the black leather jacket in example 1.

Stripes

Examples 3 & 4 experiment with bold knitted stripes in blue and green combined with orange and white fine cotton fabric. Try alternating the direction of the stripes.

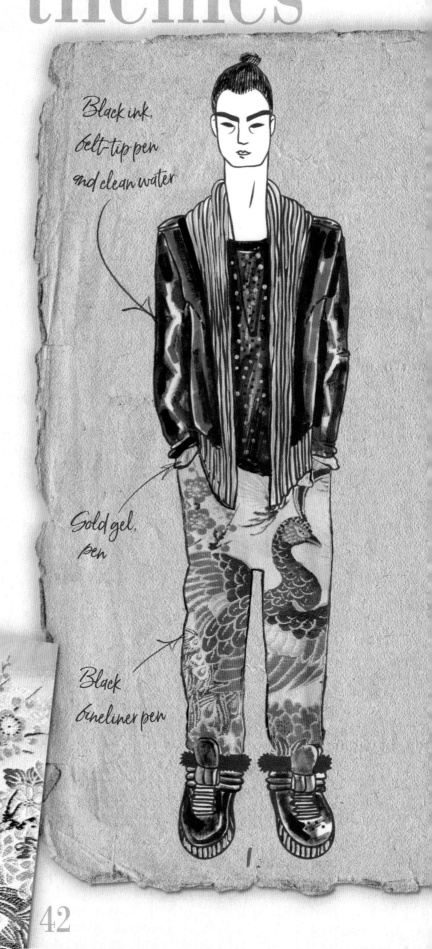

Black ink, felt-tip pen and clean water

Gold gel, pen

Black fineliner pen

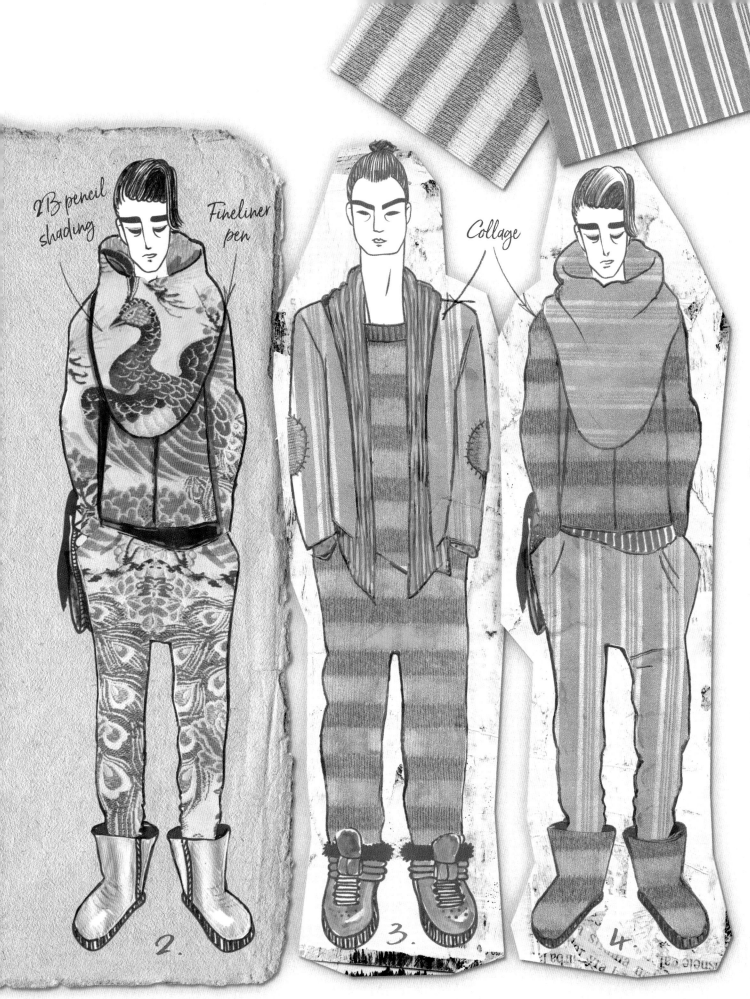

2B pencil shading

Fineliner pen

Collage

2.

3.

4.

43

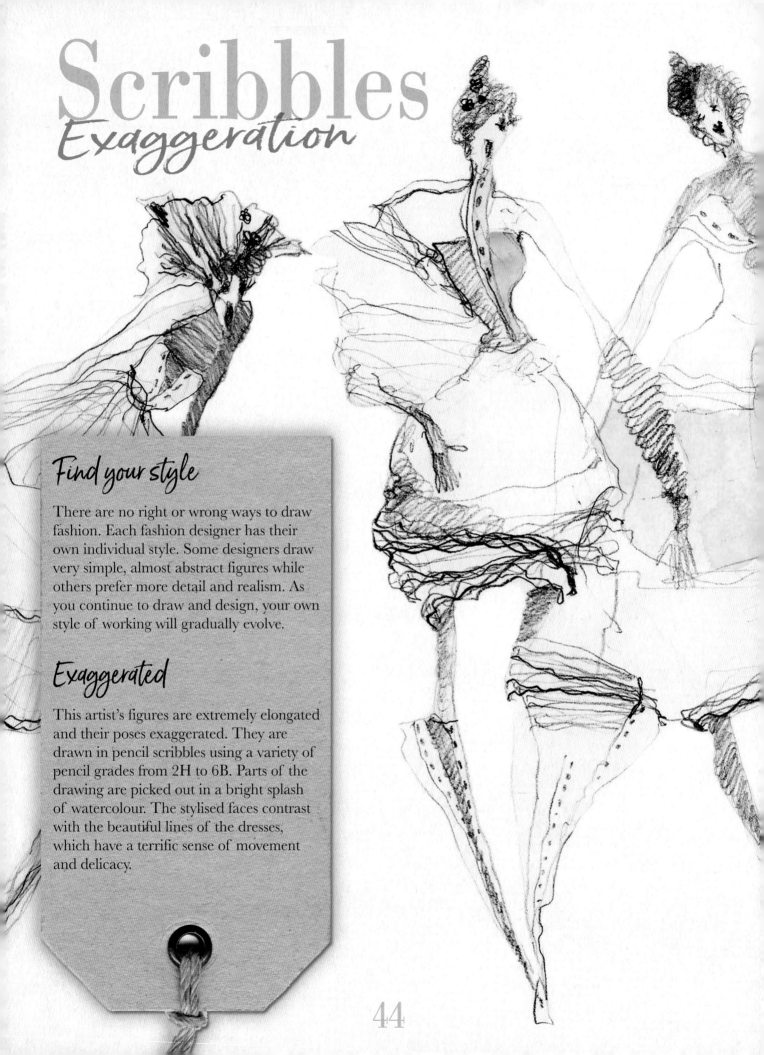

Scribbles
Exaggeration

Find your style

There are no right or wrong ways to draw fashion. Each fashion designer has their own individual style. Some designers draw very simple, almost abstract figures while others prefer more detail and realism. As you continue to draw and design, your own style of working will gradually evolve.

Exaggerated

This artist's figures are extremely elongated and their poses exaggerated. They are drawn in pencil scribbles using a variety of pencil grades from 2H to 6B. Parts of the drawing are picked out in a bright splash of watercolour. The stylised faces contrast with the beautiful lines of the dresses, which have a terrific sense of movement and delicacy.

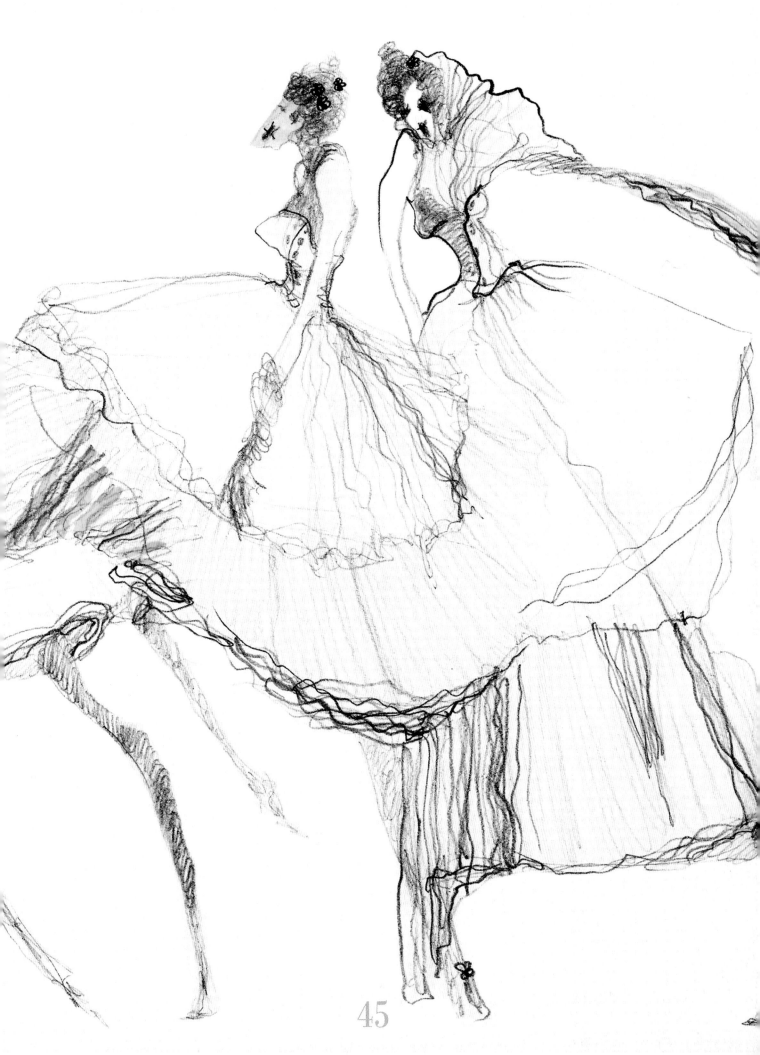

Tablet sketches
Digital drawing

Tablet or phone

It's easier to create fashion drawings on large tablets, but mobile phones are perfect for making simple fashion sketches while on the go. There are numerous apps to choose from. Try some out and find which suits you best.

The joy of drawing on a tablet is that you can redraw again and again until you are happy with the result. Study how people walk, the alternate swing of their arms and legs, and how their body moves accordingly. Then try drawing fashion figures as they walk (as shown).

Step 1
Select a brush tool set in a small size to draw the first few lines onto your tablet or phone. Sketch a stick figure, then begin adding the shape of the model's body.

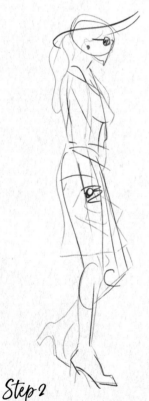

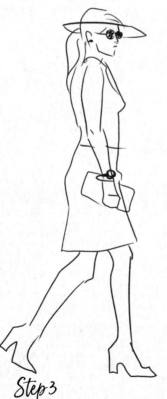

Step 2
Add another layer and move it on top of the first drawing. Add more detail, indicating the shape of the clothes, hat and accessories.

Step 3
Add a further layer again. Trace the main outline of the figure and switch off the previous layers.

Step 4
Add the final layer and switch the brush tool to colours. Colour in each area then move this layer below the previous outline drawing.

Special effects

For this technique use a pencil and paper and sketch the model's pose. Then use watercolour paints and pencil crayon to draw the coat design (below).

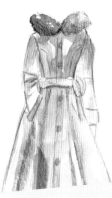

Make a finished colour drawing of the fashion figure. Scan or take a photograph of the drawing. Use a drawing app to soften the model's face and to add fine detail. Create a sense of movement and the feel of the fabric by applying an airbrush effect. Lastly, airbrush the background pale grey.

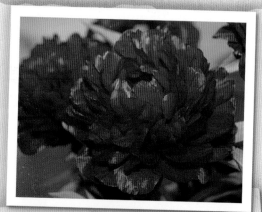

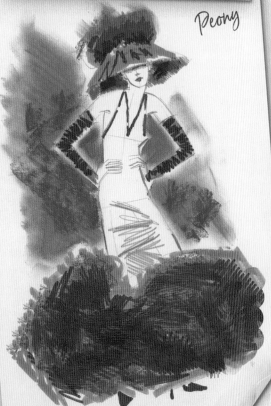

Peony

Quick sketch

This fashion drawing started as a very quick sketch executed in pencil, pastels and marker pen. The skirt and hat were both inspired by the shape and colour of a peony.

Step-by-step

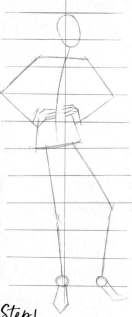

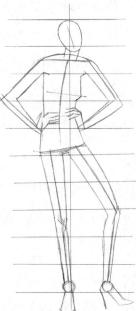

Step 1
Use pencil guidelines to draw in a simple stick figure.

Step 2
Add lines for the shape of the body, arms and legs.

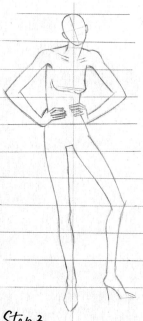

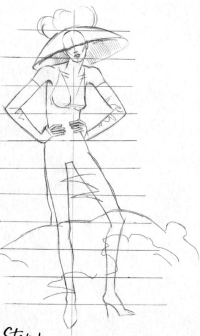

Step 3
Draw curved lines for her arms, legs, shoulders, chest and hips.

Step 4
Pencil in the shape of the hat and dress.

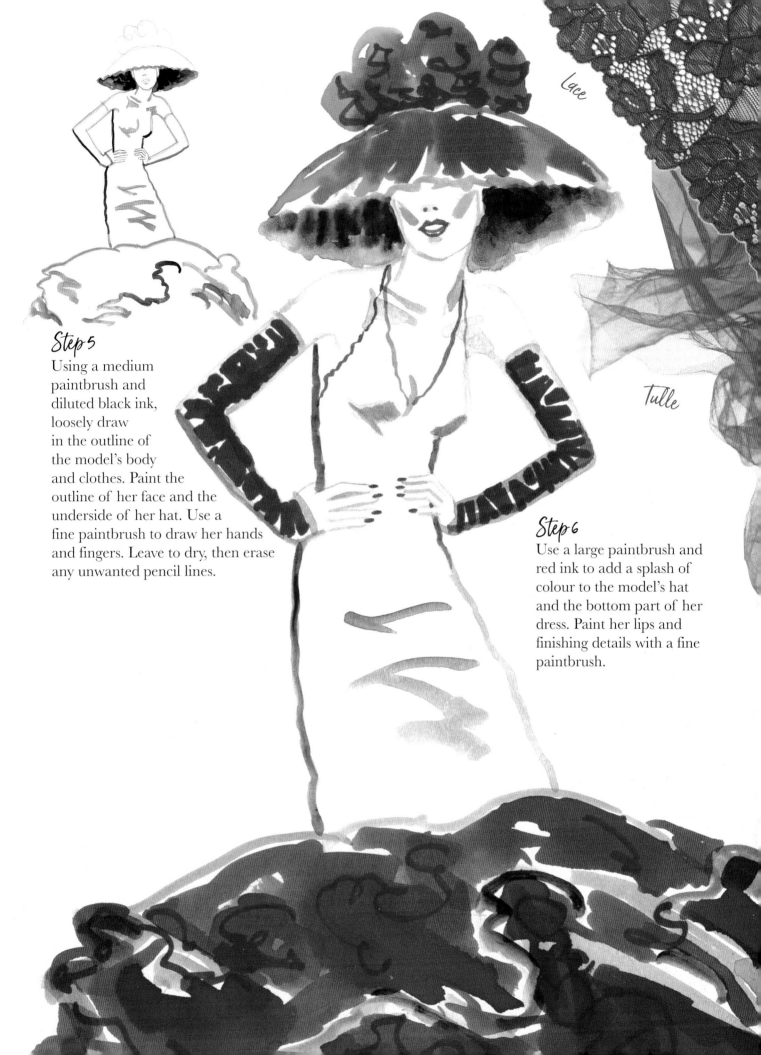

Lace

Tulle

Step 5

Using a medium
paintbrush and
diluted black ink,
loosely draw
in the outline of
the model's body
and clothes. Paint the
outline of her face and the
underside of her hat. Use a
fine paintbrush to draw her hands
and fingers. Leave to dry, then erase
any unwanted pencil lines.

Step 6

Use a large paintbrush and
red ink to add a splash of
colour to the model's hat
and the bottom part of her
dress. Paint her lips and
finishing details with a fine
paintbrush.

Nautical theme
Drawing and collage

Relaxed pose

Step 1

Using a sheet of cream-coloured paper, pencil in a series of oval shapes (as shown) to capture the model's relaxed pose. Add to the nautical theme by drawing two portholes and some decking.

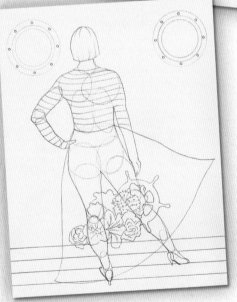

Step 2

Sketch in the flowing shape of the model's skirt. Draw a floral pattern and a ship's wheel as decoration. Sketch in the neckline and draw in curved stripes.

Step 3

Trace the shapes of the skirt, top, floral pattern, ship's wheel and the sea onto watercolour paper. Use a broad brush to paint the skirt in bold strokes of watercolour paint.

Use watercolour paints to colour in all the other design elements. Leave them to dry completely.

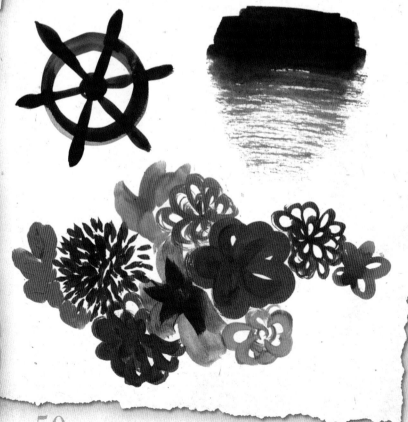

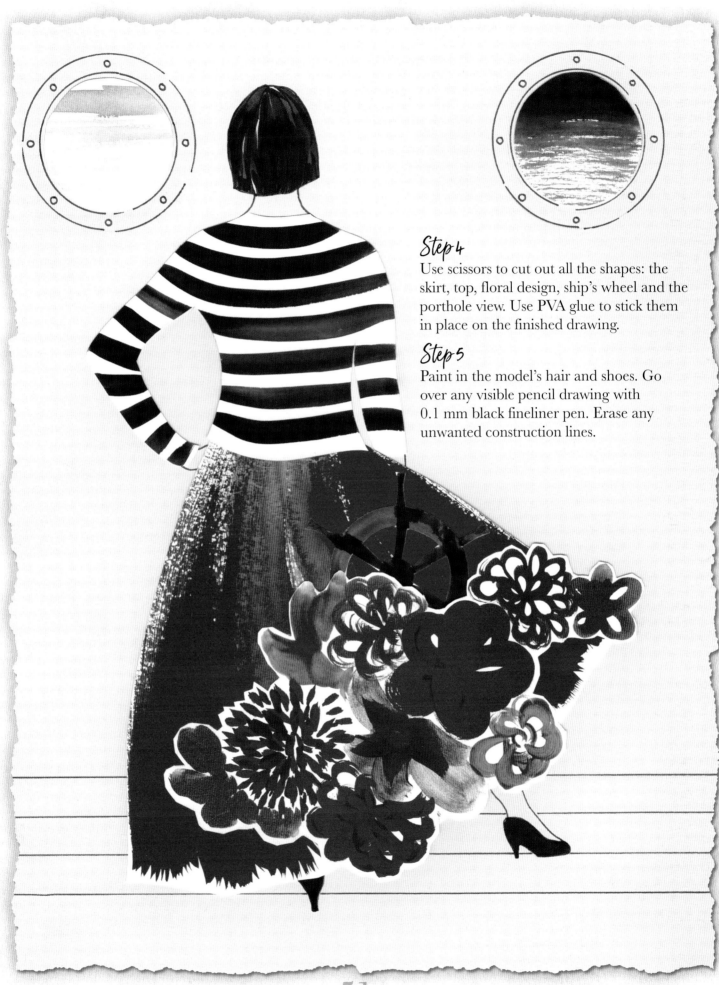

Step 4

Use scissors to cut out all the shapes: the skirt, top, floral design, ship's wheel and the porthole view. Use PVA glue to stick them in place on the finished drawing.

Step 5

Paint in the model's hair and shoes. Go over any visible pencil drawing with 0.1 mm black fineliner pen. Erase any unwanted construction lines.

Keeping a sketchbook
Creative stimulation

Ideas sketchbook

It's extremely useful to keep a sketchbook to jot down ideas, make sketches and record anything that randomly inspires you. Collect as much as possible: snippets of fabric, magazine cuttings, packaging, examples of colour combinations – anything that may help stimulate your creativity.

Personalise the cover

Try personalising your sketchbook by re-covering it with some unusual paper or fabric. You could photocopy some of your own fashion drawings and create a collage to decorate the cover.

Natural progression

Your fashion sketchbook should be like a creative journey that starts with seemingly random sketches and ideas. These will get fine-tuned, redrawn and refreshed until you have distilled them down into finished designs and ideas.

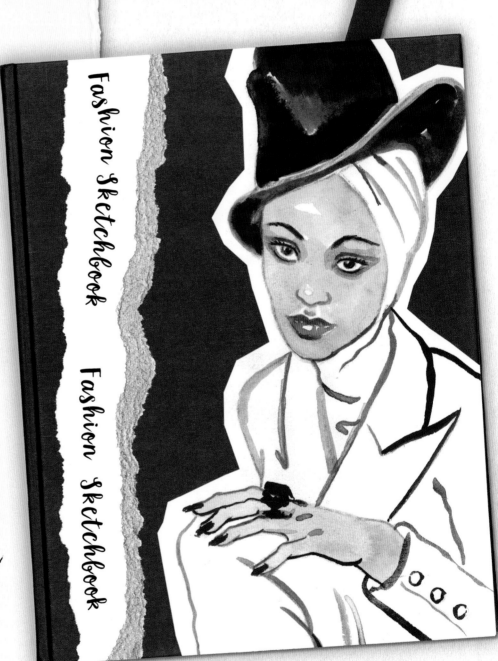

Tip: Try to use a sketchbook made of thick, robust paper that will not buckle when you glue in pieces of fabric, card and textured paper.

Exploring a theme

A sketchbook is pefect
for exploring ideas. Try
as many different ways as
possible to develop a theme
using any shapes, patterns
or textures that have
inspired you.

Create fashion collages
similar to these. Photocopy
your fashion drawing.
Pencil in the basic shapes
of each part of the design.
Trace the outlines to use as
guides. Cut out scraps of
fabric, wrapping paper and
magazines to glue in place.

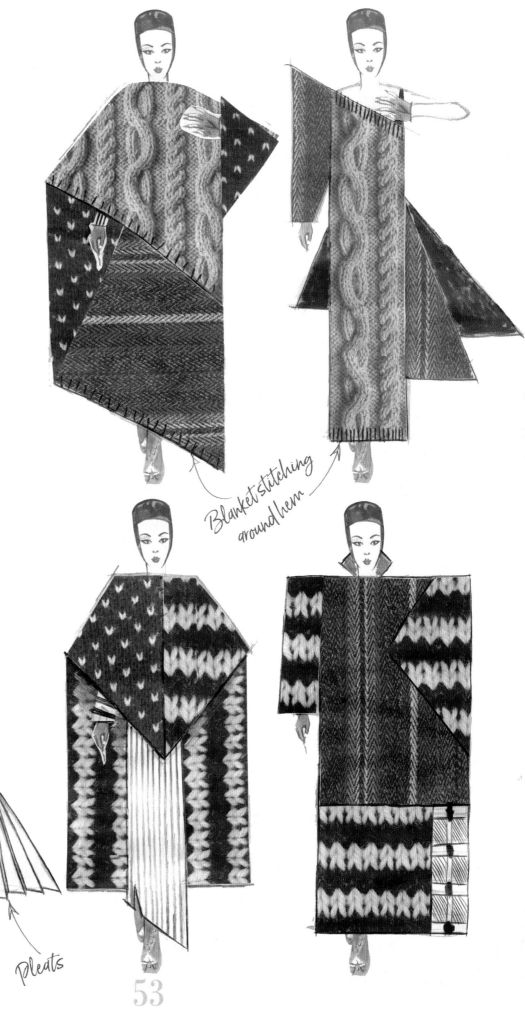

Blanket stitching around hem

pleats

Pompadour

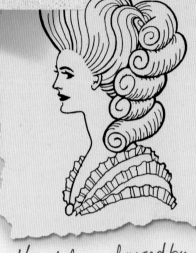

Susanna van Collen
By Hermanus Numan 1776

Hairstyle popularised by Madame Pompadour in the 18th century...hair swept up from the forehead and worn high on the head.

Georgiana, Duchess of Devonshire

Very high hairstyle! Fabulous hat!

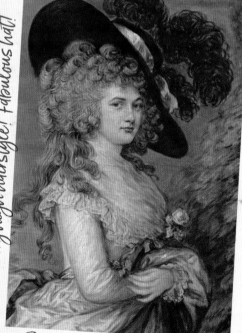

By Gainsborough Dupont (1787-96)

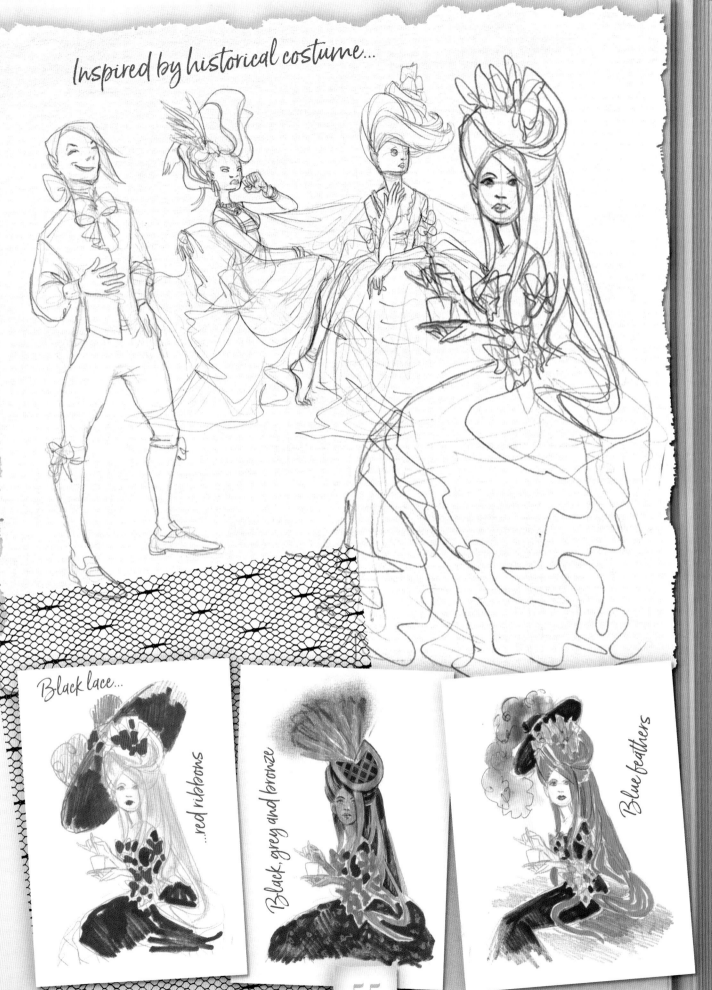

Inspired by historical costume...

Black lace...

...red ribbons

Black, grey and bronze

Blue feathers

Puffball!

Puffball-style dress with oval silhouette!

Ruched, gathered fabric! Gold and bronze sequins

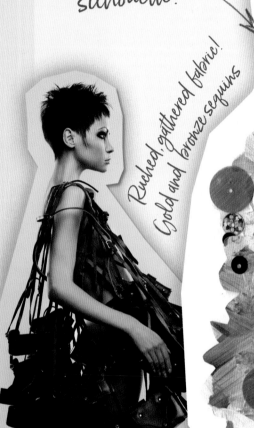

Fine, pleated silk ruffles...

Zip-up ankle boots with thick, sculptural soles...

Patent leather

Gold and bronze

Fine pleated silk

Knitted silk
turtle neck

Black chiffon
bronze silk

Bronze silk fabric
fine pleats

Patent
leather

Grey velvet uppers
with gold dots,
matt gold soles...

Bronze and
gold-coloured sequins

Shiny black soles

Urban hats

Quick sketches of men in casual clothes made in a local shopping centre...

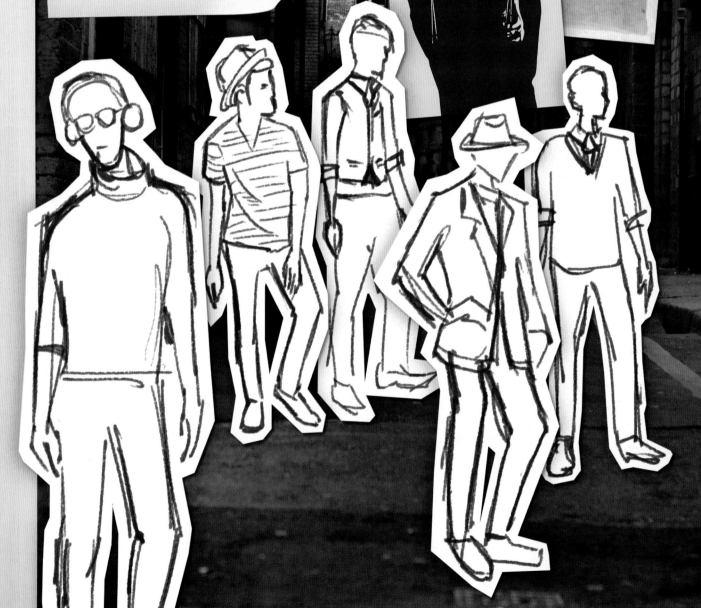

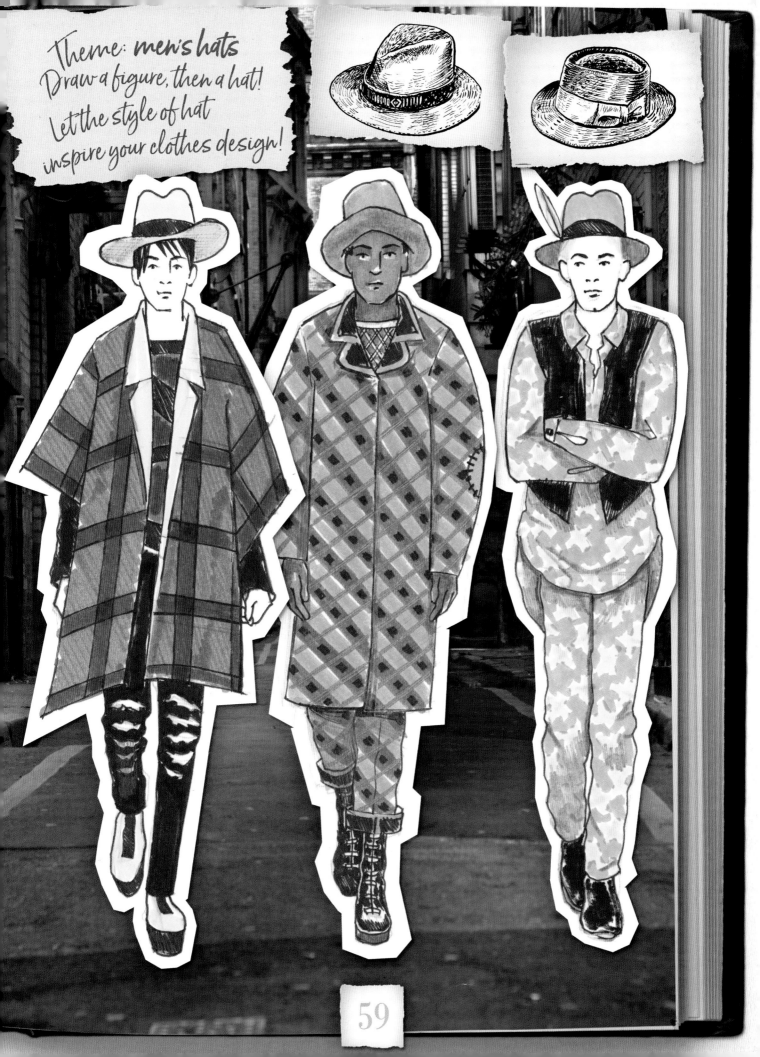

Theme: men's hats
Draw a figure, then a hat!
Let the style of hat
inspire your clothes design!

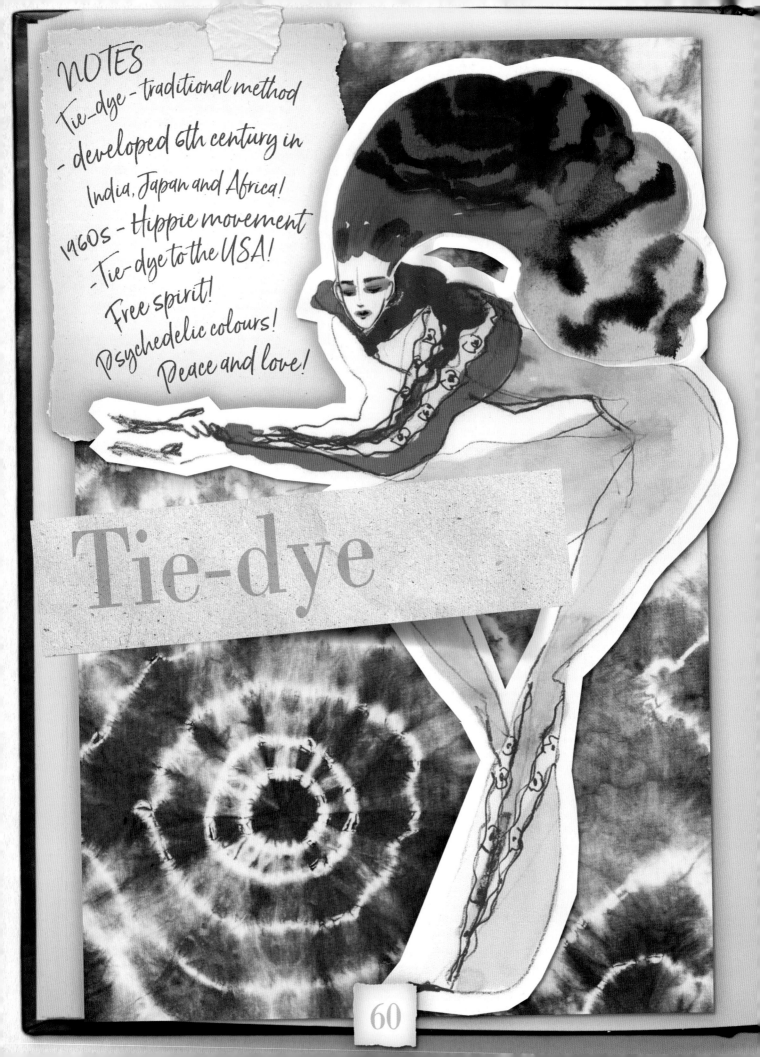

NOTES
Tie-dye - traditional method
- developed 6th century in
 India, Japan and Africa!
1960s - Hippie movement
- Tie-dye to the USA!
Free spirit!
Psychedelic colours!
Peace and love!

Tie-dye

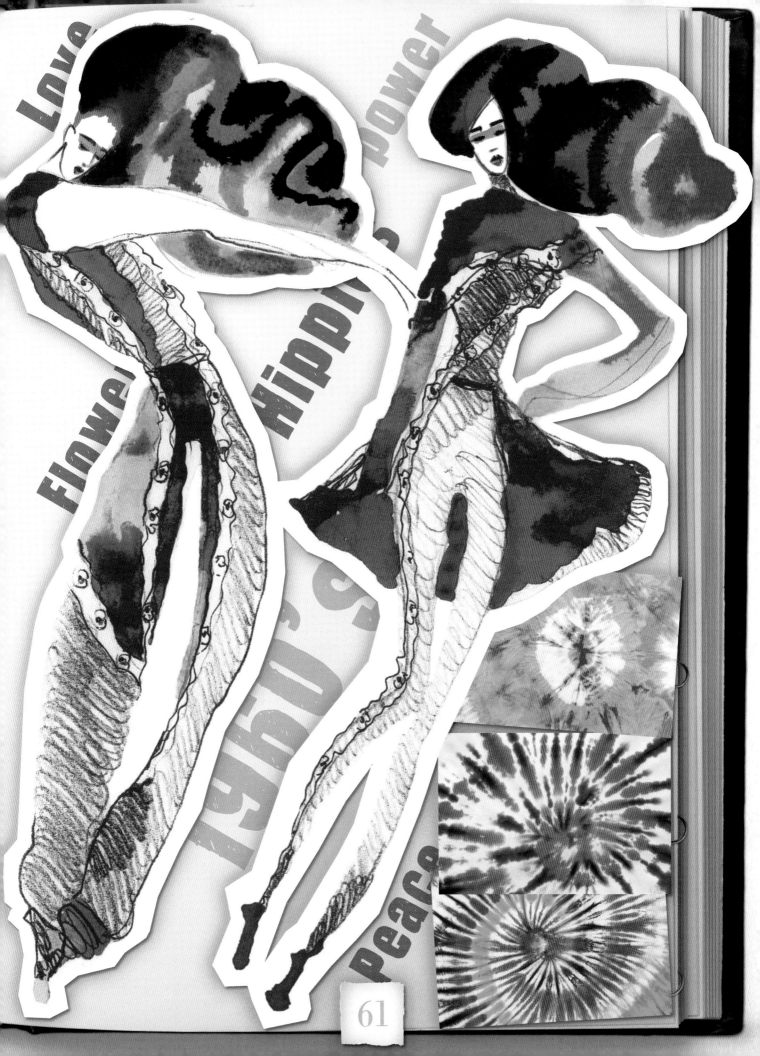

Love

power

Flower

Hippie

night s

peace

61

Glossary

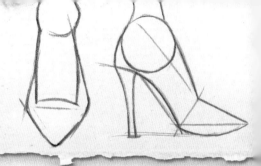

3D solid rather than flat, with the dimensions of height, width and depth.

Accessories items such as jewellery, belts and scarves that enhance the overall look of a fashion design.

Acrylic paint type of paint with a liquid, synthetic resin that binds the colour.

Analogous colours harmonious colours that lie next to each other on the colour wheel (page 12-13).

Bleed the visual effect achieved when a dark colour seeps into a lighter colour.

Blocking-in filling in large areas with solid colour.

Body proportions the comparative size relationship of various parts of the human body.

Chiffon a sheer, lightweight, plain-woven fabric with a transparent appearance.

Collage a technique for producing artwork by arranging pieces of paper, photographs, fabric and other materials onto a flat surface then glueing in place.

Collection a selection of designs sharing a common theme, shape or colour that are produced for a fashion season.

Colour palette the range of colours an artist chooses to use.

Colour temperature the coolness or warmth of a colour (blue-green is coldest and red-orange is warmest).

Cross-hatching a shading technique using two or more sets of parallel lines that criss-cross to build up tone.

Design a graphic representation, usually a drawing or sketch.

Drape fabric arranged or falling in loose, graceful folds.

Fashion figure a drawing of the human figure with exaggerated body proportions, as used by fashion designers.

Harmonious colours a pleasing colour arrangement.

Hatching a shading technique using a series of parallel lines to build up tone.

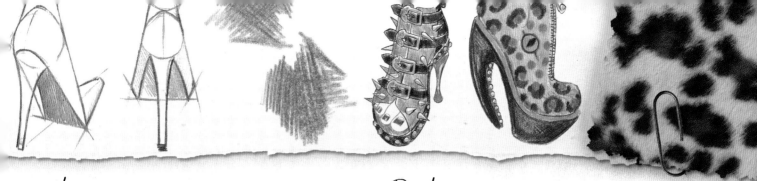

Hem the edge of a piece of cloth or clothing which has been turned over and sewn, usually at the bottom of a skirt or trousers.

Kimono a traditional, Japanese full-length robe with wide sleeves and tied with a sash.

Light source the direction from which light enters.

Limited palette a restricted number of colours chosen for an artwork.

Mixed media a technique using two or more artistic media.

Mood board a collage of images, colours and textures that make up the theme for a collection.

Pleats folds in fabric that limit fullness. Pleats can be sharp or soft.

Psychedelic strong, contrasting colours used in bright patterns.

Puffball a piece of fabric gathered up so that it bulges in the centre, sometimes used in skirt designs.

Rough an early sketch an artist makes when developing a design.

Ruffles strips of fabric, lace or ribbon tightly gathered or pleated on one edge and applied to a garment.

Seam a line along which two pieces of fabric are joined, usually by sewing.

Secondary colours the colours that are made up by mixing two of the three primary colours.

Shading methods an artist uses to represent gradations of tone.

Stylised represented in a non-naturalistic manner.

Tertiary colours the colours formed by mixing a primary and secondary colour.

Tie-dye a method of dyeing clothing or fabric. The material is tied with string or rubber bands to create patterns when dyed.

Tulle lightweight, very fine netting, which is often starched.

Watercolour wash a layer of diluted watercolour painted across the paper.

Index

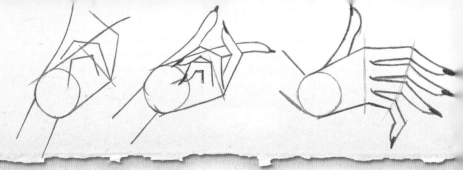